P9-CAZ-166

IMAGES
of America

RYE
AND
RYE BEACH

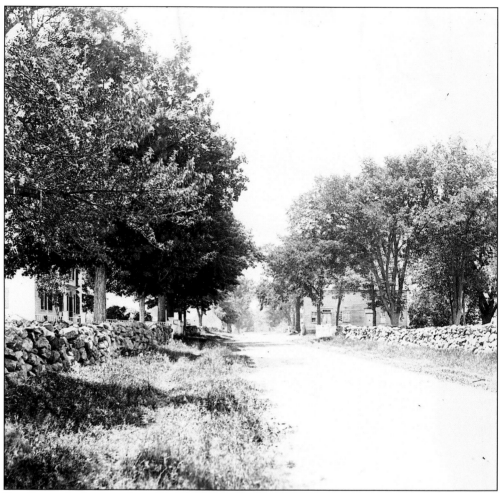

Rye Center looking south at the intersection of Lang Road sometime before 1900. The ancient Carrol & Goss store (later owned by the Rand family) can be seen in the center. The entrance shown here on the Lang Road side was later moved around the corner but still just one step off the main road. The Dr. Warren Parsons house is on the left.

IMAGES
of America

RYE
AND
RYE BEACH

William M. Varrell

ARCADIA
PUBLISHING

Copyright © 1995 by William M. Varrell
ISBN 978-0-7385-3733-7

Published by Arcadia Publishing
Charleston, South Carolina

Printed in the United States of America

Library of Congress Control Number: 2004114125

For all general information, please contact Arcadia Publishing:
Telephone 843-853-2070
Fax 843-853-0044
E-mail sales@arcadiapublishing.com
For customer service and orders:
Toll-Free 1-888-313-2665

Visit us on the Internet at www.arcadiapublishing.com

Dedicated to
the many natives of Rye who shared their family photographs and footnotes
May they be please with these results

Contents

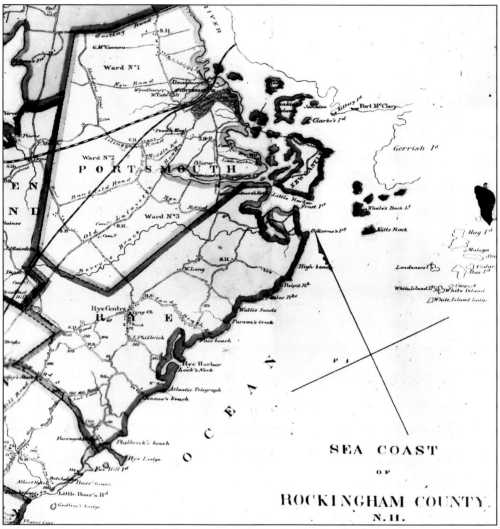

"The sea coast here is about 6 miles in extent, being nearly one third of the coast in the state. On the shore there are three considerable and very pleasant beaches, viz. Sandy, Jenness', and Wallis', to which many persons resort in the summer season from neighboring towns and the country, both for health and for pleasure." *Farmer and Moore's N.H. Gazeteer*, 1823.

Introduction

Rye is a small town with a long and colorful history. The site of the first European settlement in New Hampshire, it has been the victim of hostile Indians and sent its men and women to all the wars in our nation's history. Unfortunately, there were no cameras to record the Brackett massacre, the dying act of John Locke as he used his scythe to cut off the nose of the Indian who killed him, or the Battle of Rye Harbor during the War of 1812. Cameras were unknown during the days of the early taverns and stores, but Garland's tavern, built about 1750, is still standing and was captured on film in the early days of photography. In addition, a number of the old stores retained their original appearance for over 150 years and the remaining photographic record of them gives us a fascinating picture of how they looked in decades past. This collection, assembled over the past forty years, covers the entire town from the days of the first photographs to the present. The stately homes of the gentry, the modest homes built by the immigrants from the Isles of Shoals, famous events and well-remembered faces are all included here.

No doubt Rye's primary claim to fame is as an early and first-class summer resort that catered to the wealthy Victorians of the eastern United States. Although Rye has a number of beaches, the name Rye Beach has always indicated a social distinction rather than a geographical location. It extends to Little Boar's Head in North Hampton, but never included the beaches at the north end of town. The resort era is very well documented in photographs of the first-class hotels and the boarding houses, in many cases multiple replacements of predecessors that burned. Complementing the hotel pictures are group photographs of the guests who stayed there and the many forms of transportation that got them around town. Learn of Hawthorne and Pierce at the Ocean House, and of Rye's annexation of four of the Isles of Shoals. Although the 1813 skirmish at Rye Harbor was not a significant naval battle, see the early Farragut Hotel, named for the most famous admiral of the Civil War. These pictures dispel the notion that all Victorian tourists were senior citizens who spent their days rocking on the porch, and show that they were mainly young and active, eager to enjoy a vigorous stay in the country. Feeding the multitudes and servicing the opulence that surrounded them were the locals—natives who in many ways inhabited an entirely different world in Rye.

Although Rye's prominence was gained by its distinction as an outstanding summer resort, the natives, most of them farmers, also enjoyed a very comfortable lifestyle. Here you can see their homes, their churches, their stores, and their schools, as well as examples of their various occupations, and you can get a feeling for the routine that punctuated their daily lives. See also the activities of the two local lifesaving stations, a dramatic picture of a major rescue in progress, and the broken remains of the ship on the beach. I have also tried to detail some of Rye's contributions to the wider world: for example, by outlining the development of the Rye

office of the Direct United States Cable Company, the first totally undersea telegraph cable between the United States and Europe.

Although many of these photographs were taken by native town photographer A.R.H. Foss, he was not the only local camera man. An Edward H. Williams took many of the Rye Beach pictures in the 1880s. A news item from 1886 states that Mr. L.H. Griffin of Amesbury, Massachusetts, had been at the beach taking pictures for fourteen summers. The resort also created enough interest to be recorded by stereoptician views taken by Davis Bros. of Portsmouth and Hobbs of Exeter, among many others. After the turn of the century, Clarence Trefery took many pictures of tourists and schoolchildren. I have attempted to make sure that each of these local artists are well-represented in this book, although there are probably still many old pictures of Rye to be found and identified. Although many people find the oldest pictures most interesting, included here are also more recent views that many take for granted, but which prove that Rye has not stood still for the last seventy-five years.

Since most old photographs were taken in bright sunlight, it is not difficult as you read this book to take yourself back to a Rye summer of well over a hundred years ago. Visualize a tint of green for the fields and the sea, a blue sky, and bottle-green coaches with yellow wheels. Imagine the sound of the surf and the clatter of horses dashing by, pulling an overburdened coach. Listen for the echo of a hotel band and take yourself back to the last century of a still very vibrant town with a classic location and a secure place in history.

William M. Varrell
April 1995

One
Rye Center

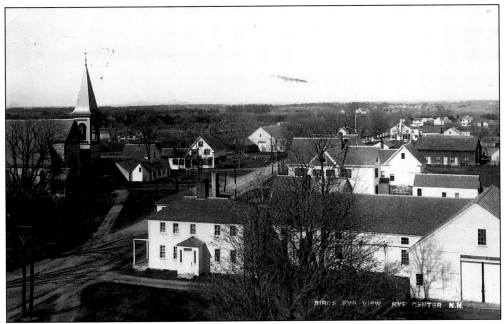

Rye Center looking north from the belfry of the Congregational Church, c. 1920.

Rye Center before the first Christian church burned in 1888. The old Garland tavern can be seen in the center, at the top of Center Hill.

At the turn of the century the Center, or Wedgewood, School occupied the site of the current Rye Junior High School.

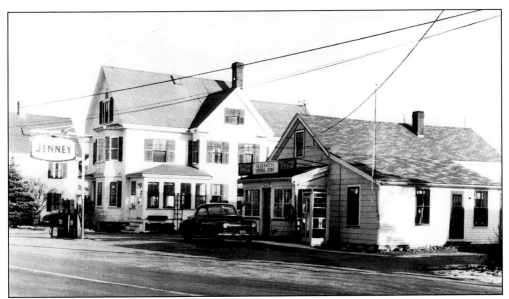

Jenness' Store and Post Office at Rye Center was also the information center of Rye until it was replaced by the new post office in 1964.

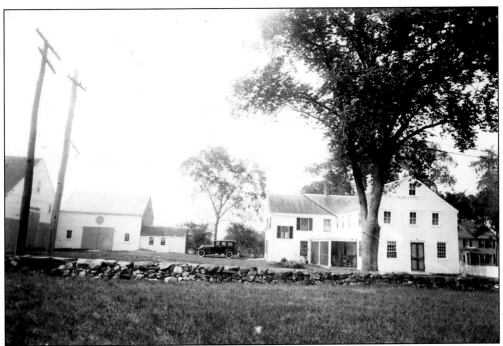

Blake Rand's store at Rye Center, another store that had not changed in over a hundred years. By the 1940s it sold little more than candy and tobacco, but it still had the typical, old-fashioned store interior—a stove sitting in a box of sand surrounded by a group of well-worn chairs. Local children could inspect an antique toy Noah's ark while their parents paid their taxes. Originally only a stone post protected the front corner from traffic, but in 1968 the house was moved back to allow for the widening of Lang Road.

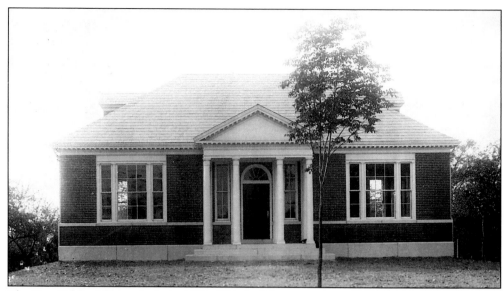

The Rye Public Library, built in 1911. This building, constructed in 1910, was a gift to the Town by Mary Tuck Rand.

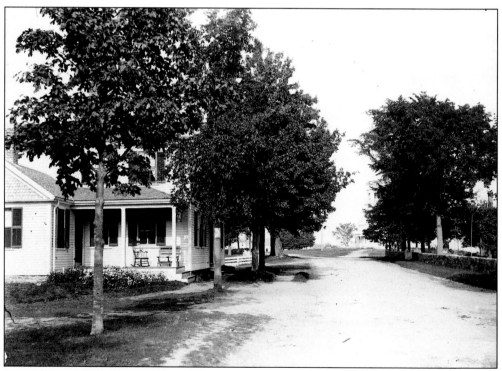

Rye Center with the house of Lewis Walker on the left.

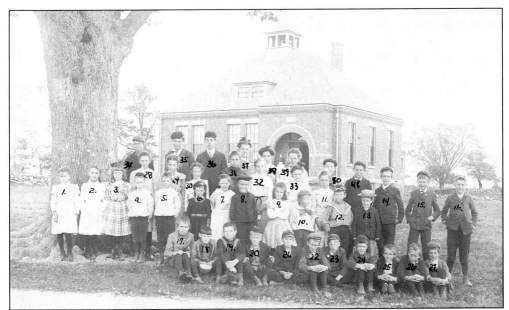

Students at the Center School *c.* 1900. They have been identified as follows: 1. Edna (Sanborn) Hayes; 2. Lucy (Marden) Raynes; 3. Elizabeth Caswell; 4. Ralph Downs; 5. Leslie Downs; 6. Elizabeth Goss; 7. Sarah Locke; 8. John Parsons; 9. Corinne Parsons; 10. unknown; 11. Leona Libby; 12. Willis Tory; 13. unknown; 14. Albert Hanscom; 15. Daniel Libby; 16. Dexter Ramsdell; 17. Justin Libby; 18. Horace Rand; 19. Harry Odiorne; 20. Walter Foster; 21. James Rand; 22. Joseph Tucker; 23. Arthur Foster; 24. Justin Hanscom; 25. Raymond Walker; 26. unknown; 27. Mertron Drake; 28. Edna (Tucker) Smart; 29. Emma (Matthews) Becker; 30. Margaret Locke; 31. Marion Caswell; 32. Donna Berry; 33. Marge (Tucker) Little; 34. ? Caswell; 35. Blake Ramsdell; 36. Ben ?; 37. Edith Odiorne; 38. Ada Rand; 39. unknown; 40. Alonzo Berry.

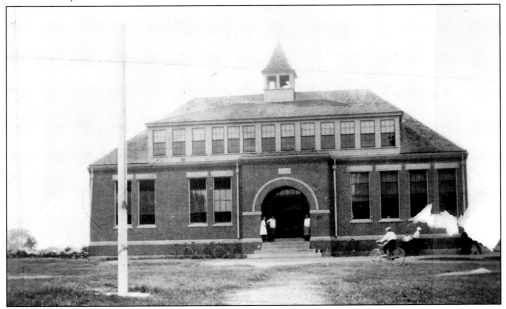

The Center, or Wedgewood, School as it looked when it burned on Valentine's night, 1932.

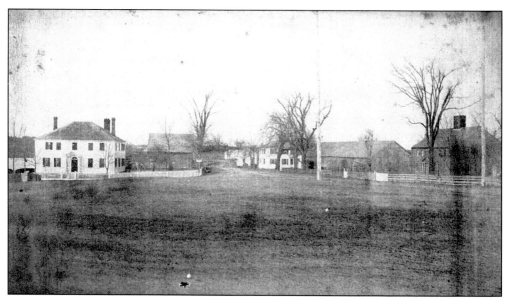

Rye Center in the 1890s. In the foreground is the Town training field and on the left is the home of Langdon Parsons, author of the 1905 *History of Rye*. On the right is the old Garland tavern. This picture was taken prior to 1893, when the tavern was painted for the first time and the barn was torn down as part of the renovation to become a summer home for Boston industrialist and railroad president R.R. Higgins.

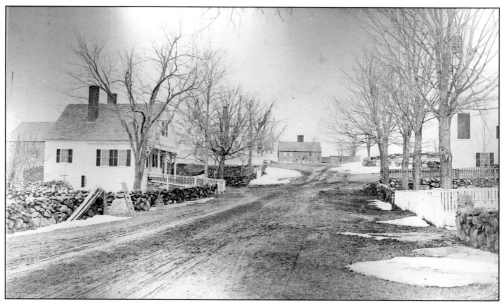

Center Hill was so hard on horses with a heavy load that they were often detoured via Fern Avenue. The new town hall, dedicated in 1873, is on the right.

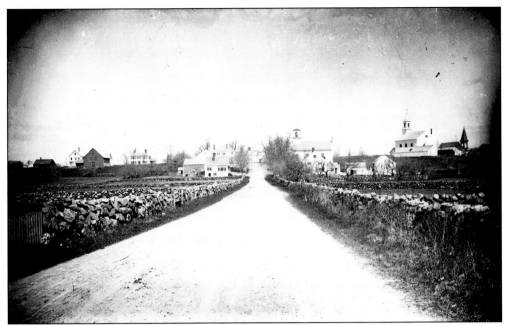

Rye Center from the present cemetery gate. Note the horse-sheds behind the Congregational Church and the tower of the "Brown Church," built in 1889.

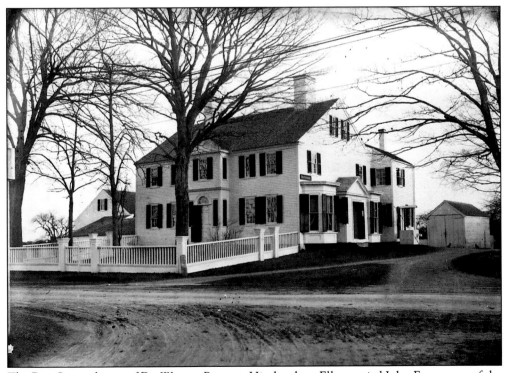

The Rye Center home of Dr. Warren Parsons. His daughter Ella married John Fraser, one of the English cable station operators.

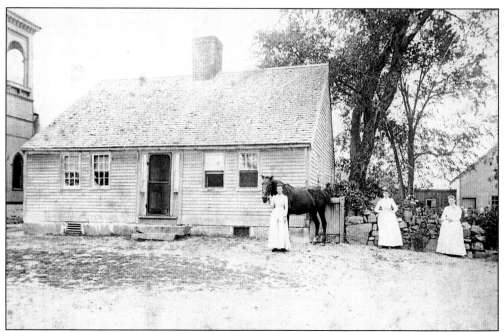

The William J. Walker residence at Rye Center. The steeple of the "Brown Church" is on the left. Shown are Lillian Walker, Isabel Walker Berry, and their mother Mary Robinson Walker (who died in 1899). This house was abandoned when a new Walker home was built next door.

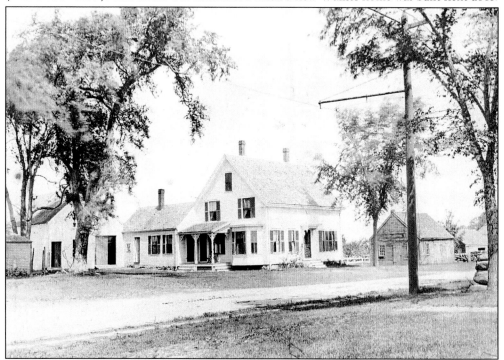

William Walker's new house and blacksmith shop at Rye Center was adjacent to the old house pictured above. The pole for the trolley wire indicates that this picture was taken after 1900. Walker's blacksmith's shop can be seen on the right.

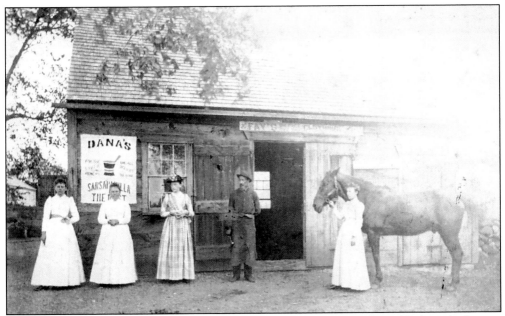

The Walker family gathered for a photograph outside William Walker's blacksmith shop, c. 1900.

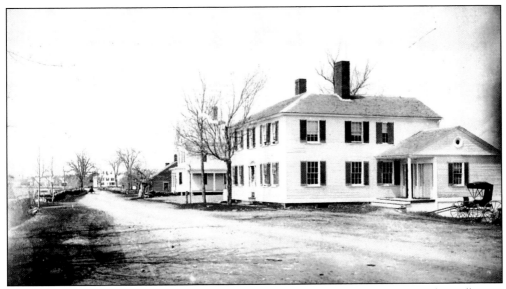

The Lewis Walker residence at Rye Center was built by his father, Jonathan Towle Walker, in 1836. Lewis Walker's wife, Mrs. Julia Foss Walker, was the sister of the well-known local photographer, Alba Harrison Foss.

ENTERTAINMENT
—AND—
Strawberry Supper,
AT THE
Town Hall Rye, N. H.
THURSDAY EVENING JUNE 8TH. 1893.

PROGRAM.

1. MUSIC, ORCHESTRA.

"Fun in a Post Office."

CAST OF CHARACTERS:

Johnnie O'Hagan, jealous of Rufus, Mr. Thomas Whenal.
Rufus, "Who sweeps out de Offis." Mr. John Jellison.
Joe Green. P. M. Julia's brother Mr. C. W. Spear.
Charlie Brown, in love with Julia, Mr. John Whenal.
Mary O'Herne, in love with O'Hagan, Miss Annie Locke.
Julia Green, Joe's sister, in love with Charlie Brown.
 Mrs John Jellison.

3. Song, Miss Data Garland.
4. Recitation, Miss Josie Perkins.
5. Song, Miss C. Gertrude Brown.
6. Recitation, Master Ernest Varrell.

DRAMA, IN TWO ACTS.

"THE IRISH LINEN PEDLER."

CHARACTERS:

PAT O'DOYLE, a linen pedler, Mr. John Jellison.
MR. FLANNAGAN, Mr. Frank Brown.
MR. DARLING, Mr. C. W. Spear.
MISS DARLING, Miss C. Gertrude Brown.
MRS. WADE, Mrs. John Jellison.
MOLLIE, Miss Fannie Garland.

SYNOPSIS

SCENE I. Pat at the farmhouse of Darling. Latter has planned an elopement with Mrs. Wade, which he wishes to conceal from his daughter, who has planed an elopement with Flannagan. The father, daughter and Flannagan each buy a set of tablecloths, but by a series of mistakes, Mrs. Wade gets them all. Pat falls in love with Molly, and thinks Flannagan his rival. Pat's account of their relationship in the ould country.

SCENE II. Four valises packed. Pat inspects them and gets them badly mixed. Is bribed to silence. Discovers all. Persuades Molly to elope with him.

SCENE III. At a hotel, The valises tell queer tales. Explanations. Pat proposes to economize by "lumping" the marriage ceremony.

A rich and varied social life was never the exclusive preserve of Rye Beach's summer community; Rye natives knew how to take care of themselves just as well as the visitors.

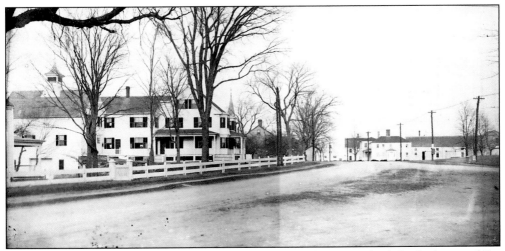

Looking north from Rye Center, *c.* 1900. The large residence on the left, the home of Dr. Peterson at the time this photograph was taken, was later the home of Justin D. Hartford, editor of the *Portsmouth Herald*.

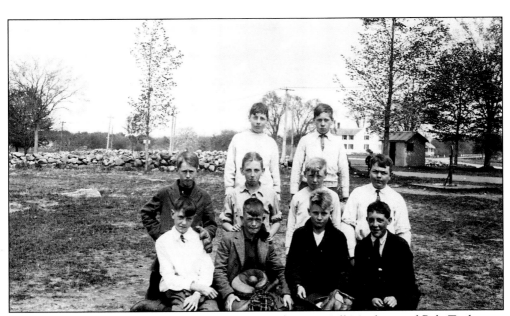

Ball players in front of the Center School in the mid-1920s. Bill Moulton and Bale Tucker are in the second row. In the background are the Adams Drake House that burned in the early 1940s and the trolley car waiting room in Grange Park.

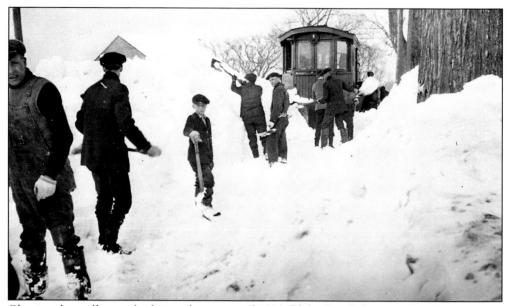

Clearing the trolley tracks during the winter of 1920. Blake Rand's barn roof can be seen over the snow bank.

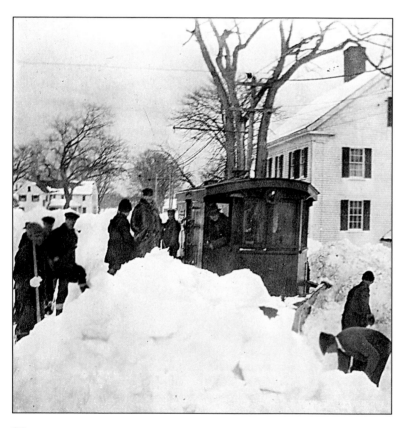

Digging out the trolley car in front of the home of George Perry in 1920.

Two
Farmers, Fishermen and Others

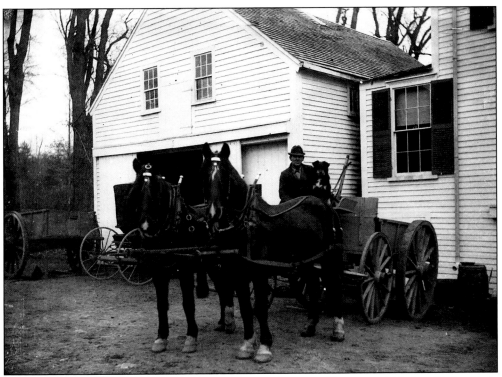

Farmer and teamster Alfred Philbrick with his team, Lucie and Laura, and his dog, Carlo. Carlo attacked, and was subsequently killed by, the first scheduled trolley car that ran through Rye. Philbrick carried local farm products, as well as ice and coal for the Rye Beach hotels, furniture for cottage renters (they would have their furniture shipped to North Hampton by rail and then carried by cart to their summer homes), and stove kindling for the cottages at Straw's Point. He also drove the hearse, his first funeral being that of the local stagecoach driver Adams Drake.

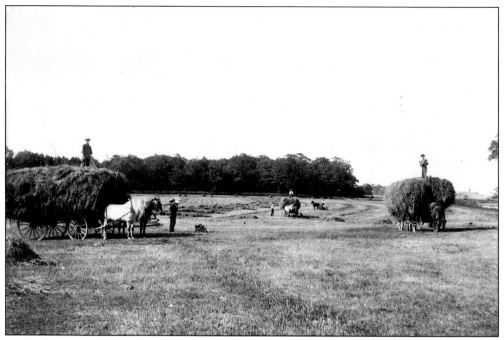

In the days of horsepower, haying was a fact of life. In this photograph, one man can be seen drinking switchel, a hayer's refresher made up of cold water, molasses, ginger, vinegar, and brown sugar. It was sometimes said that the addition of a little hard cider got the hay to the barn twice as fast.

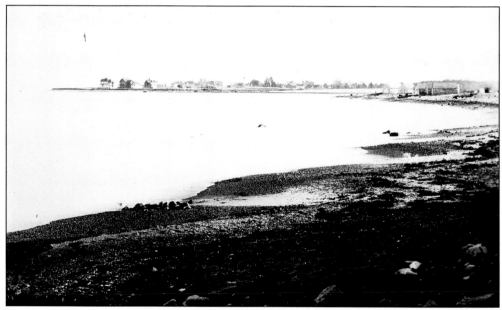

Rye Beach fish houses with the cottages on Little Boar's Head in the background.

Rye Beach fish houses, where fishermen from the south of the town kept their boats and gear. Some of these buildings were destroyed by storms and others burned as a result of an accident with the fire used to heat tar to waterproof the boats. Today only one remains, and it is now used as a summer cottage.

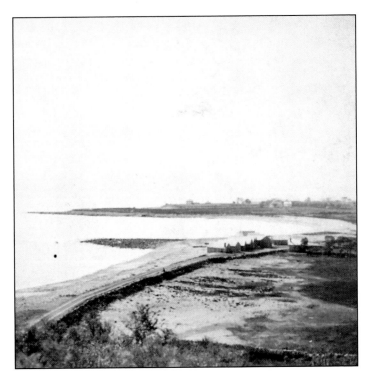

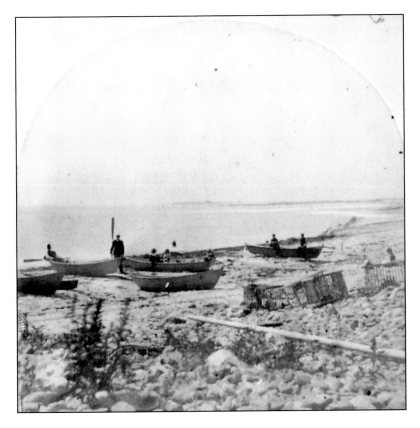

Since most of the shore was too exposed for a wharf, boats were just pulled up on the beach.

23

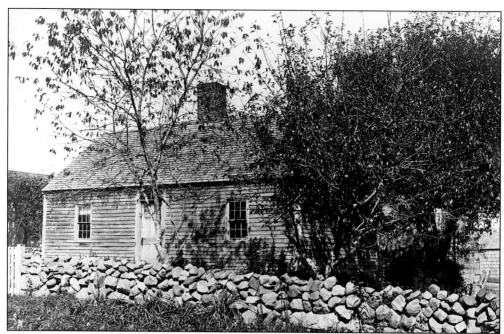

The Josiah Marden house on Washington Road, later the home of Dan Libby. Typical of the Sandy Beach homes built by the "immigrants" from the Isles of Shoals, this house was spoiled by a 1920s modernization (so-called) and gutted in a fire in 1954. It is now the home of Sylvia Bartlett.

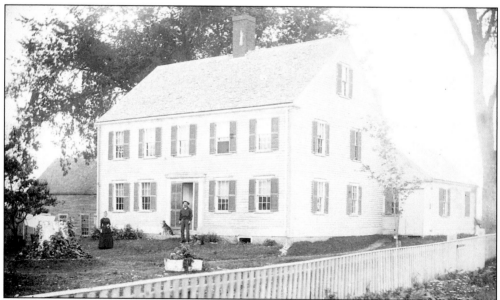

The Odiorne homestead at Odiorne's Point. This house was restored by Mr. Ralph Brown after being used as a speak-easy during the Prohibition era and as a barracks during World War II. During the Depression, the Odiorne family operated it as a summer tea room and then rented it to a family. Their tenants turned out to be impossible to evict and became notorious in the area due to the many rumors that they were selling all the antiques in the house and running an illegal drinking establishment.

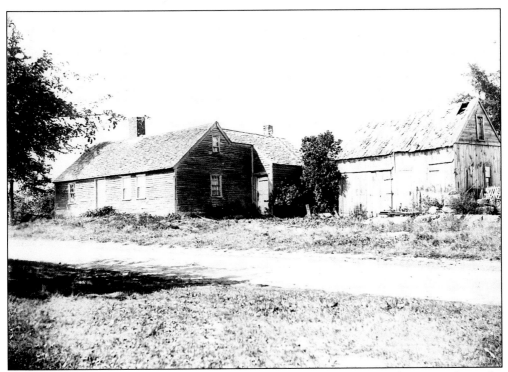

The Sandy Beach home of Civil War veteran Joseph Berry. The house was later moved to make room for a modern house for his son, Roscoe. Berry's other children were a son, Alonzo, and two daughters, who became Ruth Marden and Blanche Foss.

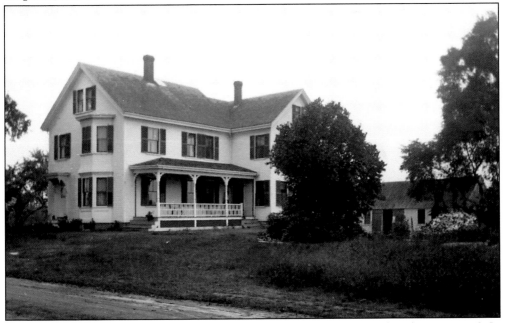

The Washington Road home of the Roscoe Berry family, who moved in for Christmas 1903. In this photograph we can see his father's house, which had been moved to the back yard to be used as a shed.

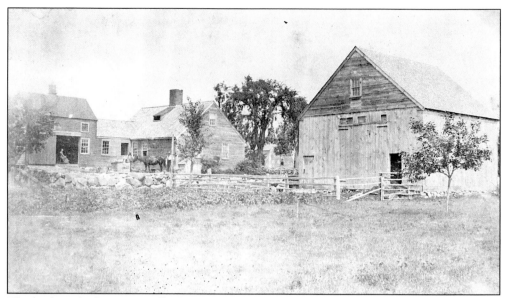

The back yard of Tom Varrell's farm on Sandy Beach Road. Sandy Beach Road later became Washington Road, and it retains that name today.

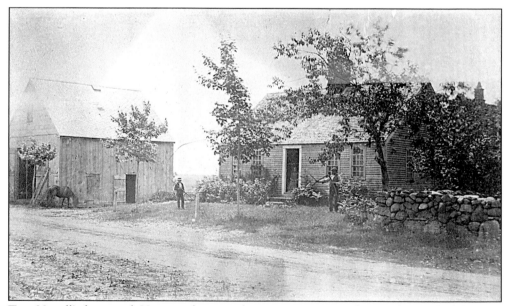

Tom Varrell's front yard. He was a farmer, a fancy stonemason, and a member of the lifesaving station crew. During the Civil War he had been the assistant lighthouse keeper at the Isle of Shoals.

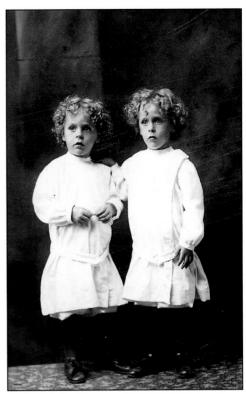

Tom Varrell's twins, born May 11, 1907.

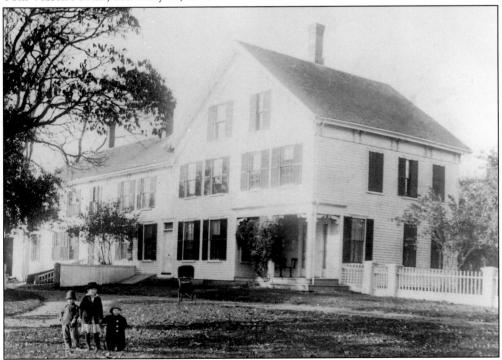

The Daniel Webster Philbrick farm on Central Road. This farm would become the last working farm in Rye.

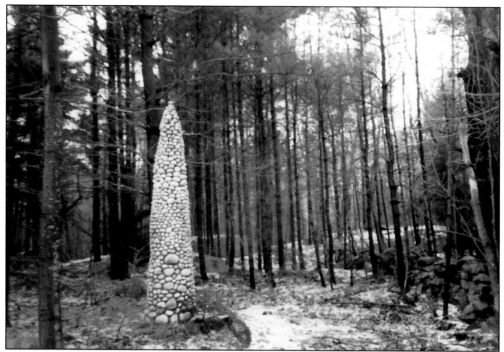

The sole remainder of Fred Marden's fantasy land of towers, turrets, and designs that he built with white stones that he carried home from the beach in his pockets.

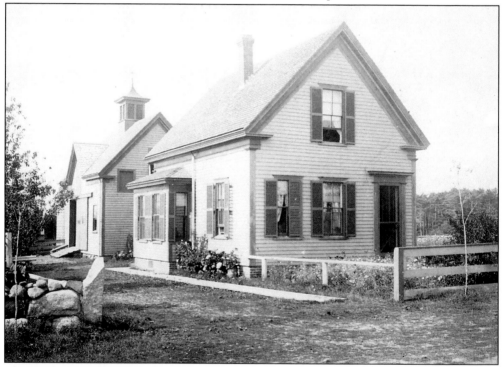

The Washington Road home of Richard Varrell. This home was later occupied by Josie Rand and Edwin Bromfield.

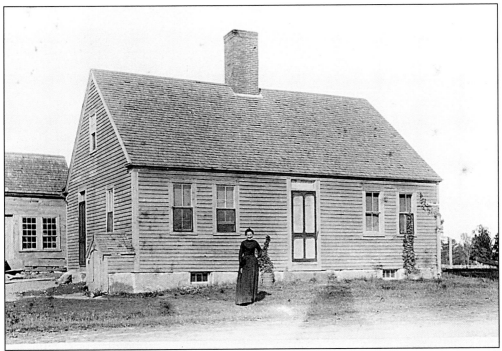

The John Towle Marden house on Sandy Beach Road, the home of Florence, Fred, and Newell Marden. It has been beautifully restored by Libby Marden, the widow of Newell's son Robert.

Newell Marden, perennial selectman and town moderator.

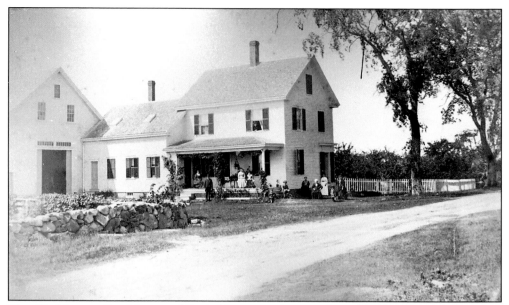

The Washington Road home of Rye's Victorian photographer, Alba R. Harrison Foss. His photography studio was originally located in a small building across the street, but was later moved to the Spinney property on Ocean Boulevard and converted to a summer cottage.

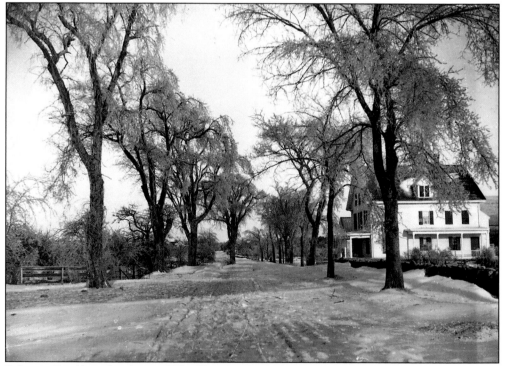

Sylvanus Foss' boarding house, "The Elms," is shown here in its prime.

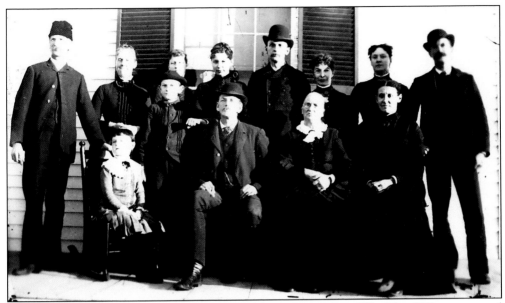

The extended Foss family posing for a photograph on the porch at "The Elms." The owner and his wife are on the left; his brother (the photographer) with his first wife on his right are in the middle of the back row, and their daughter Bertha is seated. The others are Lewis Walker with his wife on the right, and Cotton and Alice Jenness (seated).

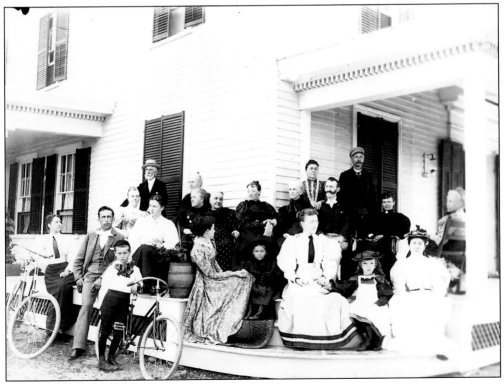

At "The Elms," *c.* 1897.

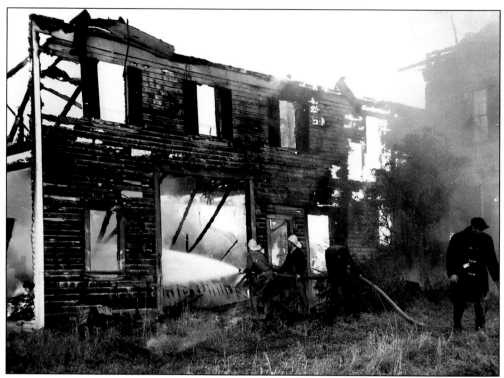

Bertha Foss' home burning in a terrible fire on October 22, 1959. Fire Chief Charlie Gordon can be seen in the foreground. (Courtesy of the *Portsmouth Herald*)

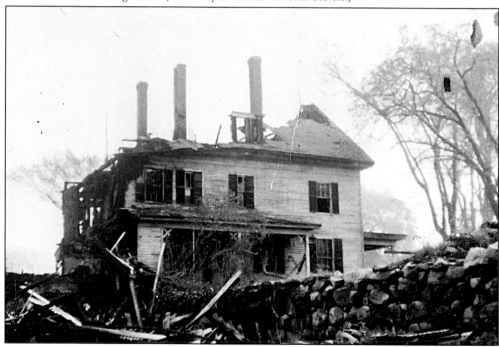

The 1959 ruins of Bertha Foss' home; no longer the starting point of Adam Drake's morning mail run to Portsmouth.

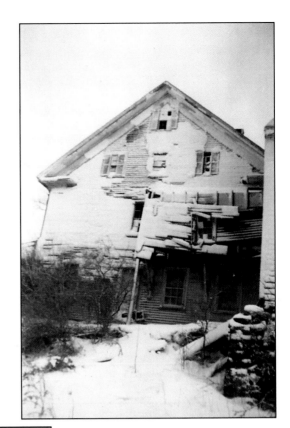

Sylvanus Foss' boarding house near the end of its lifetime in the 1950s. The barn had suddenly collapsed under the weight of snow and the rest of the house was coming apart at the seams.

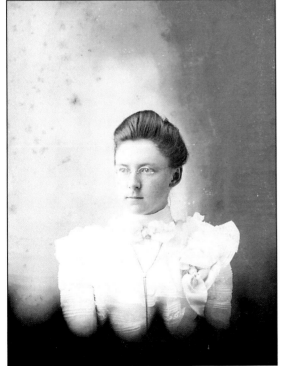

Bertha Foss. This former darling of Foss Beach never married, but rather stayed home to take care of her parents. When they died she lived as a recluse in the family's former boarding house, always dressed in layers of clothing to keep warm in the big old house. After years of coping alone with no central heating, running water, or electricity, she was finally moved to a Portsmouth nursing home when she was burned out by an arsonist in 1959.

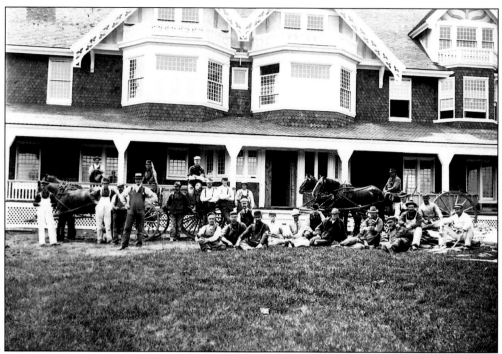

Local craftsmen at the Diblee Estate. The estate was built by Marshall Field of Chicago as a wedding gift for his sister.

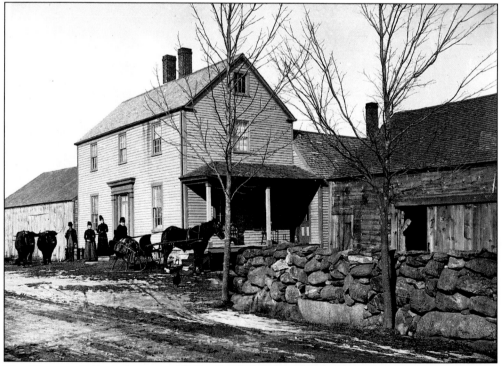

The Ebenezar Odiorne home on Wallis Sands Road, with Mr. Odiorne and his team of oxen posing out front. Sadly, this house was recently torn down.

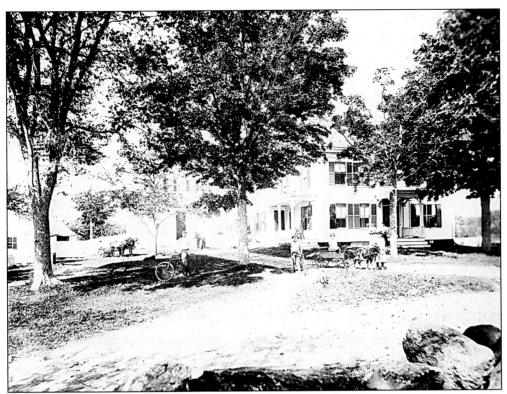

The Charles Remick home on Brackett Road. The Remick family's opposition to a pipeline crossing their land was one of the key factors in preventing Aristotle Onassis from building an oil tanker terminal at the Isles of Shoals and a refinery at Great Bay.

The Brackett Road home of Eben Seavey next to Seavey's Creek in East Rye. Rye natives referred to this structure as the Pioneer Bridge. In the foreground is a bath house built over the creek. The Seavey house, later the home of the Wendell family, burned in 1988.

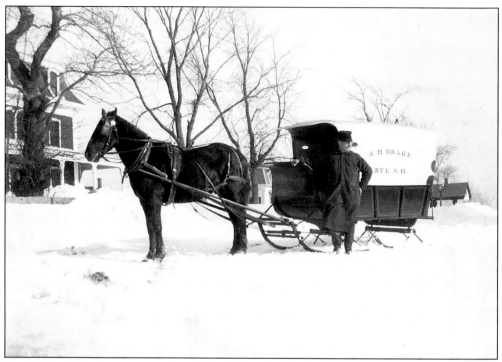

Bert Drake delivering meat to Batchelder's Hotel at Little Boar's Head in North Hampton. Note that the meat wagon is on runners to enable it to run smoothly on the snow-covered roads.

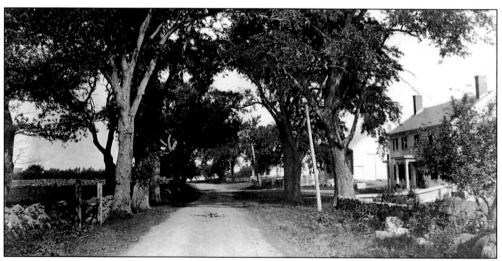

The Reuel Shapley house on Washington Road in West Rye. This poor man had two brothers killed in the Civil War, a wife who died during childbirth, and a sister killed when thrown from a wagon.

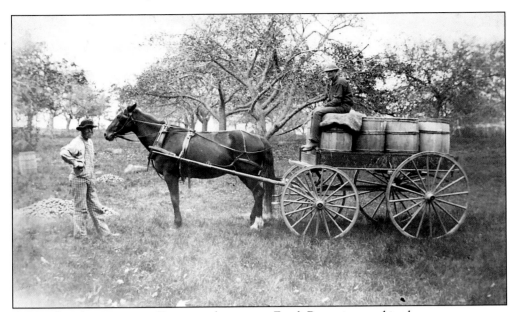

A West Rye farming scene. Farmer and carpenter Frank Boyce is seated in the wagon.

Rye Center butcher, George Perry. In the 1940s the meat house was moved down Washington Road halfway to the beach and attached to Carl Howe's barn, also moved from next door, to create a three-family home.

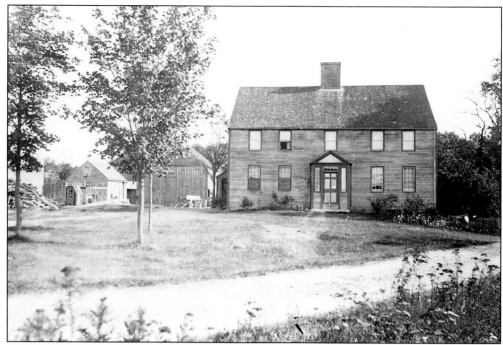

The Amos Seavey house at Odiorne's Point on Route 1A was built about 1700. At the time of the Revolutionary War, the original owners kept slaves named Phillis and Cato. In the 1930s, the house was run as Miriam's Tea Room. Most of the houses at Odiorne's Point were demolished in the the early 1940s when the land was commandeered by the government as the site for coastal defense installation Fort Dearborn.

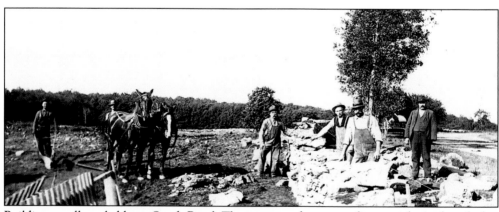

Building a wall, probably on South Road. The one-armed man standing at right is identified as Howard Rand. The second man from the right is Emmons Clark, and Charles Rand is driving the team of horses.

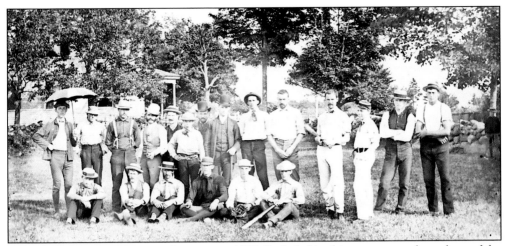

A baseball game on a summer afternoon in 1886. Included in this group are at least three of the Englishmen who manned the local telegraph cable station. Those identified are William Fraser, John Fraser, Patrick Reib, and George Brown.

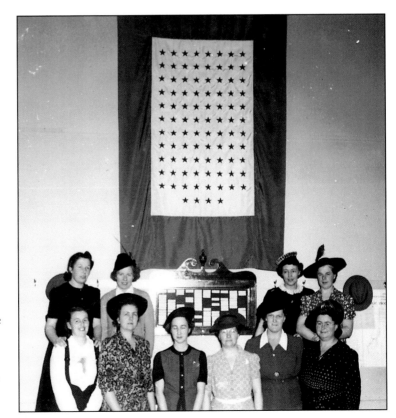

The Darning Needle Club made this flag that hung in the town hall to recognize those who served in World War II.

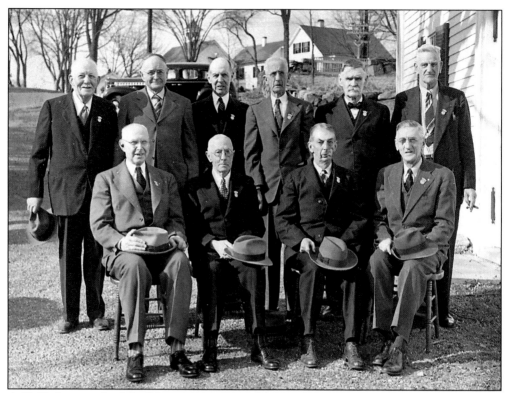

A 1947 photograph of the fifty-year members of the Junior Order of Mechanics. When people spoke of town fathers, these were the men they were talking about. Included are, from left to right: (front row) Willie Philbrick, Willie Locke, J.H. Brown, and Ernest Foss; (back row) Elmer Caswell, Chester Drake, Edward Sawyer, Horace Berry, Willie White, and Irvin Rand.

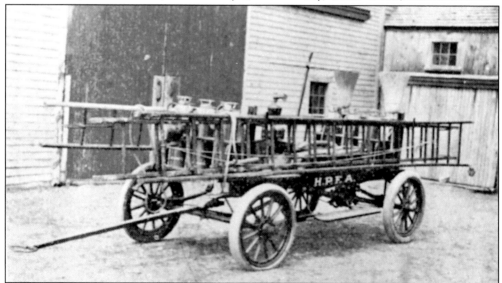

Rye's turn-of-the-century fire equipment. This horse-drawn ladder and chemical truck belonged to the Home Protection Fire Association and was kept at the Lang's Corner home of Mrs. Annie Canney.

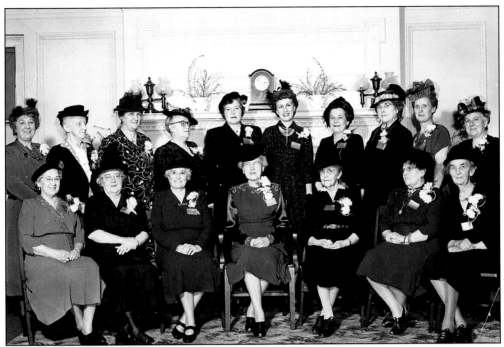

The past presidents of the Every-Other-Tuesday Club gathered together in 1950. If the members of the Junior Order were the town fathers, these movers and shakers were very much their female equivalent. Shown are, from left to right: (front row) Mrs. Wm Philbrick, Bessie Locke, Mrs. Conors, Mrs. Cotton, Mrs. Alba Foss, Emile Swenson, and Miss Agnes Brown; (back row) Vera Slater, Mrs. Willard Jenness, Mrs. Garland Wynott, Ida Hooper, Mary "Joe" Varrell, Laura Kirk, Evelyn Scaratt, Mrs.Chester Drake, Vivian Volkman, and Ms. Dorothy Gibby.

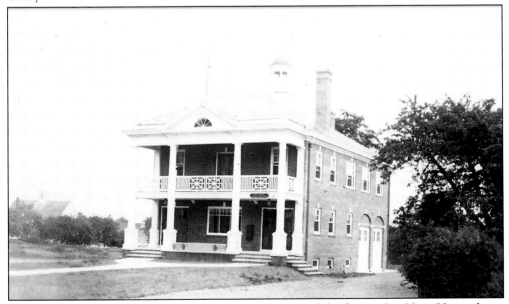

The Rye Beach Post Office was constructed on the site of the former Sea View House dance hall in 1919. Its upstairs community hall was the clubhouse of the Every-Other-Tuesday Club.

~~A~~tlantic Literary Club, = Rye, N. H.		
MEMBERS	**RECEIVED**	**SENT**
MRS. JOSEPH W. BERRY - -	*April 3*	*April 10*
" SYLVANUS W. FOSS -	" 10	" 17
" ARTHUR M. FOSS - -	" 17	" 24
" CHARLES M. REMICK -	" 25	*May 6*
" BLAKE H. RAND - - -		
MISS AGNES M. BROWN - -	*may 9 '15*	" 16
MRS. ARCHIBALD FINLAYSON		" 23
" ALFRED C. PHILBRICK	" 23	" 28
" J. JENNESS RAND - -	" 28	*June 5*
" GEORGE B. ROGERS - -	" 28	" 12
" FANNIE S. MARDEN - -	*June 5*	
" FORREST C. VARRELL -		*April 3 1915*

The Atlantic Literary Club met in private homes to discuss uplifting subjects of current interest. Each member subscribed to a different magazine that circulated among the members, circulation being controlled by a paper label, such as the one pictured above.

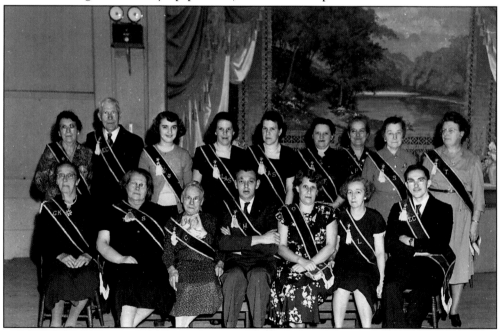

Officers of the Rye Grange in the late 1940s pictured in front of the scenic curtain at the town hall. This colorful curtain that rolled on a heavy drum ensured that every performance ended with a loud thud.

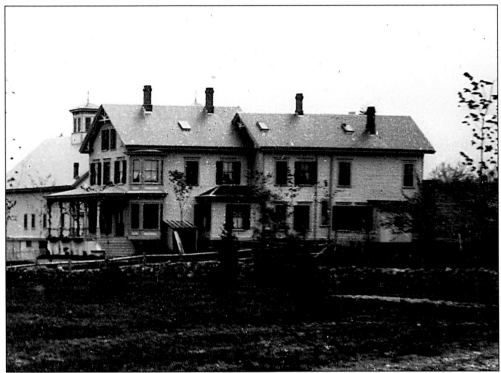

The original Perkins' Farm on Perkins Road. This farm burned in the early 1930s. Mr. Perkins' daughter Josephine married Parker Straw, superintendent of Manchester's great Amoskeag Mills.

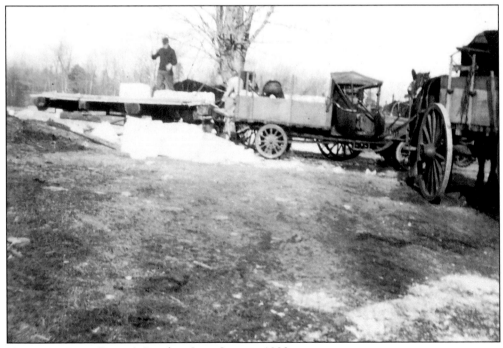

Harvesting ice at Brown's Pond on Love Lane in 1923.

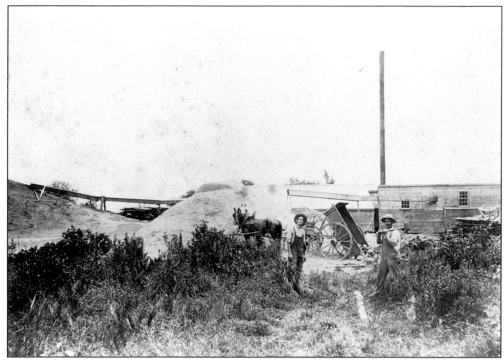

Edgar Rand at his sawmill. The mill continues to operate as a key service for construction projects in Rye.

Austin Jenness' sawmill on Central Road at Red Mill Lane.

Three
Getting Around Rye

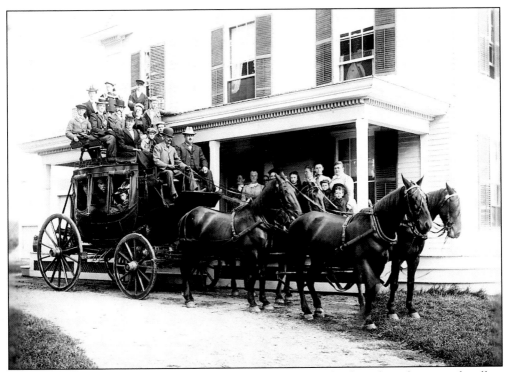

Adams Drake's coach at Foss' boarding house. The coach, said to have been brown with yellow trim, is about to set off on the morning mail run to Portsmouth. Many of those on the coach are members of the extended Richardson family from Wakefield, Massachusetts.

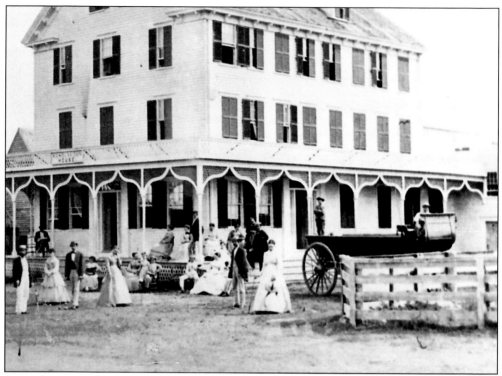

A Civil War-era photograph of the Washington House. The "barge" in the foreground was that era's form of mass transit.

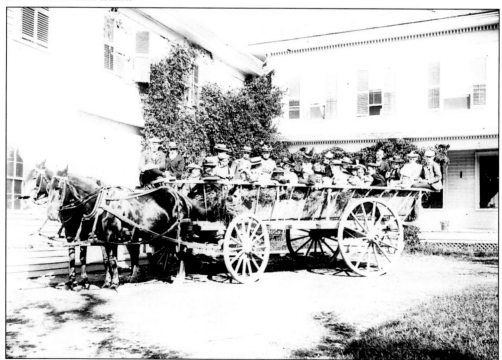

If the boarding house didn't have a barge, there was always a hay ride.

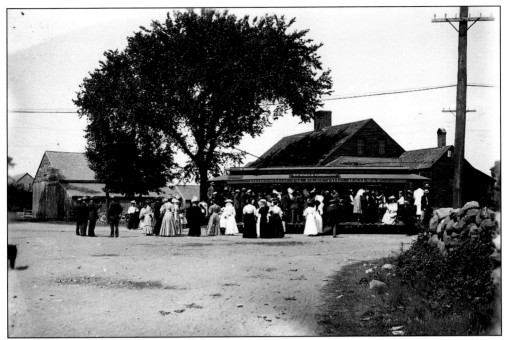

A trolley car at Lang's Corner in 1918. This crowd was going to Portsmouth on the Fourth of July for a multiple launch at the Shattuck Shipyard.

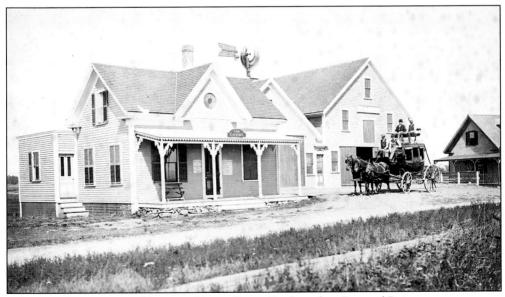

Adams Drake's casino and livery stable on Ocean Boulevard at Concord Point.

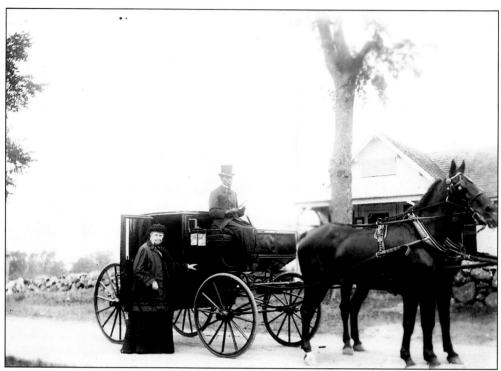

There's no question that the "carriage trade" had their pictures taken at Foss' Washington Road studio.

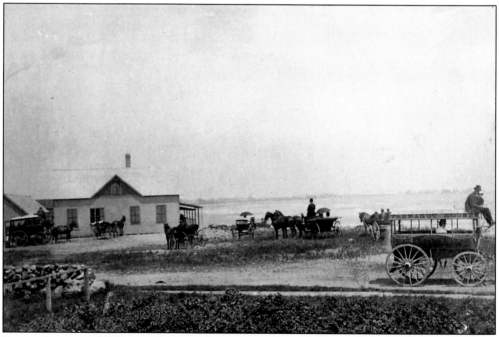

Fancy carriages and Fifth Avenue-style omnibuses at Locke's Bath House, another sign that Rye catered to the "carriage trade." One source reports that one of the wealthy summer families, the Hobson family, arrived at Rye Beach in 1905 with four different carriages.

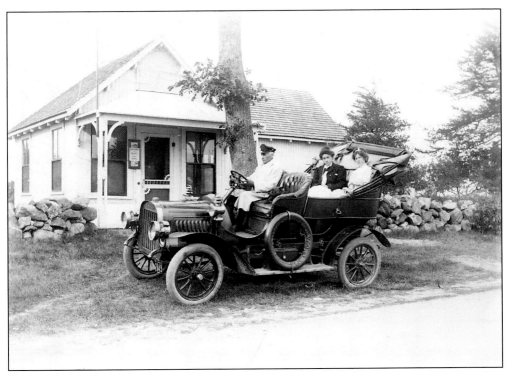

Many changes were captured on film by Foss over the years. With the invention of the horseless carriage, the local photographer was soon being called upon to take photographs of the local and visiting wealthy in their "modern" vehicles.

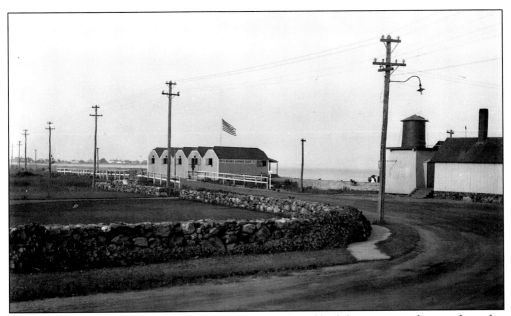

Sawyer's Bath Houses were built in 1883 after various hotel bath houses were destroyed in a fire caused by children playing with firecrackers. In later years, Edward Sawyer worked as the Rye Beach "livery for hire" and would drive the old ladies from the Farragut to York Harbor for tea.

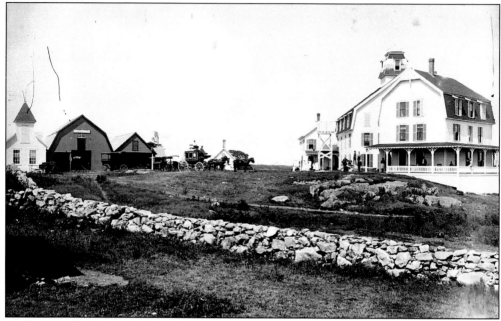

A photograph taken in back of the Ocean Wave showing the many activities involved with running a summer hotel. A chronic shortage of water prompted the use of windmills at many Rye hotels and boarding houses.

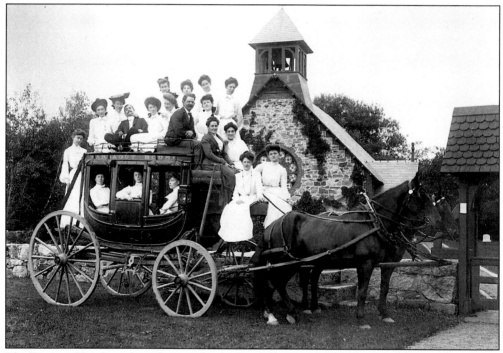

The Farragut Hotel coach at the new St. Andrew's Episcopal Church. According to the records of the Abbot and Downing Company (the company that built the coach), it was a deluxe-style English Tally-Ho, painted bottle green with yellow wheels. It cost almost $2,000 while a standard coach cost less than $1,000. (Courtesy of the Rye Historical Society)

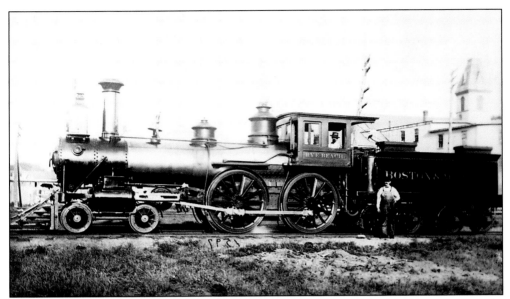

The former Eastern Railroad locomotive "Rye Beach." The Eastern Railroad generated tourist loyalty by naming their engines after the different resorts served by the railroad.

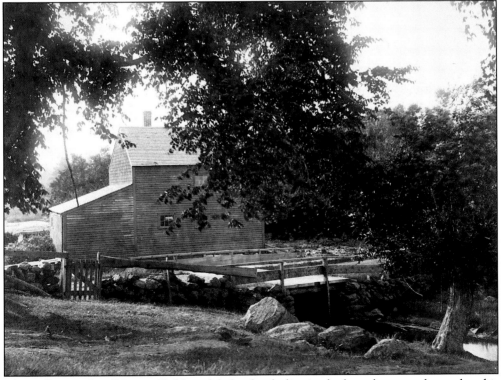

The Mill on Red Mill Lane. Children delighted in hiding in the branches over the road at this spot and hearing the screams of the ladies on the top seats of the coach as it tore by so close to the trees that the branches almost whipped their hats off.

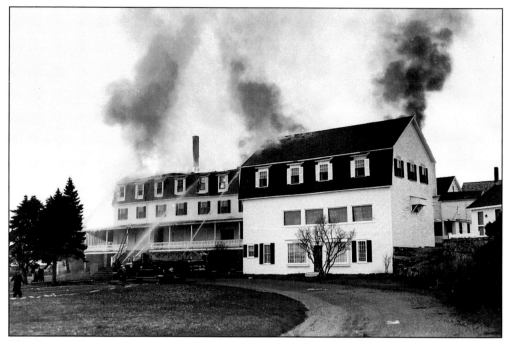

The Ocean Wave becomes another victim of the local epidemic. This huge fire occurred on April 23, 1960. If the fire started where reported, a large built-in, beveled mirror later seen in an antique shop would have had to be removed beforehand. (Courtesy of the *Portsmouth Herald*)

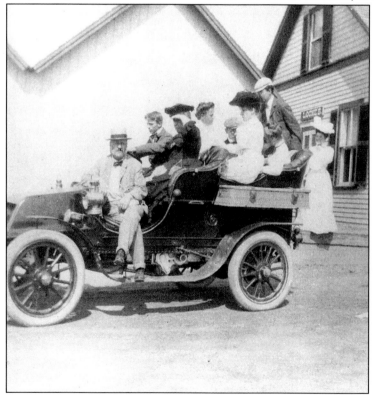

The Francis Drake and the Chisholm families at Locke's Bath House. These were the only hot saltwater baths north of Newport, Rhode Island. They were at the peak of their popularity in the days of Victorian tourism before each hotel room had its own private bath.

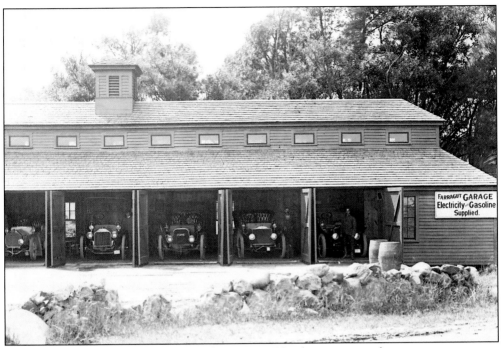

In the early 1900s the bowling alley at the Farragut Hotel was converted to a garage.

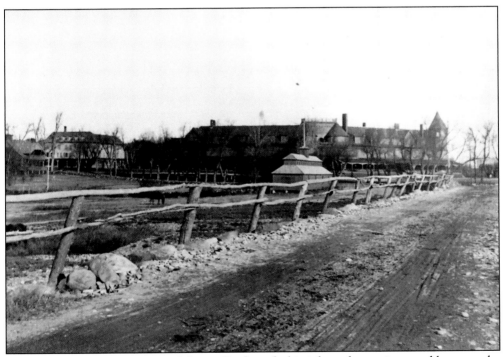

Prior to the 1901 construction of Ocean Boulevard, this is how the carriage road between the Farragut Hotel and Little Boar's Head looked. In the foreground is the hotel bowling alley. The old Atlantic House is on the left.

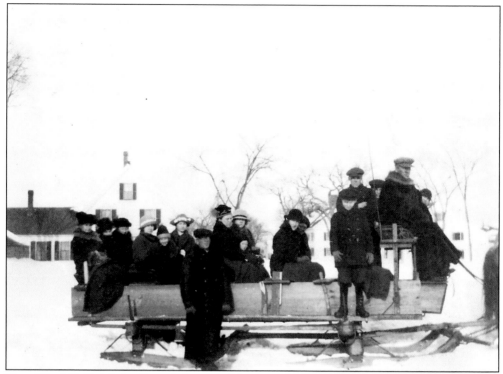

The Alfred Philbrick family and their neighbors on their way home from church in 1923. In deep snow, horse-drawn sleds were still the most reliable way to get around. Irvin Philbrick is the man standing beside the sled.

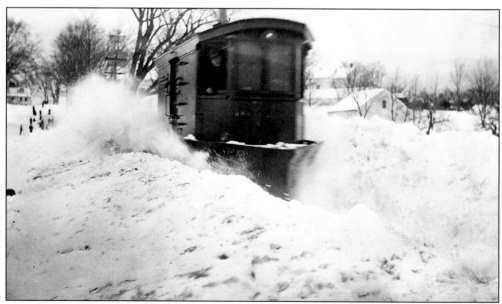

A trolley car plowing snow by the cemetery in 1920.

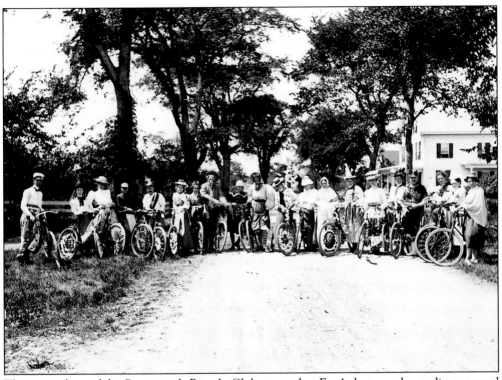

These members of the Portsmouth Bicycle Club stopped at Foss' photography studio to record their "costume" outing. Some of them appear to be men dressed as women.

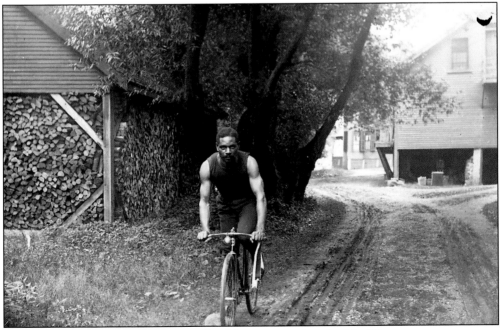

A waiter at the Farragut. At least one Rye Victorian was into bodybuilding.

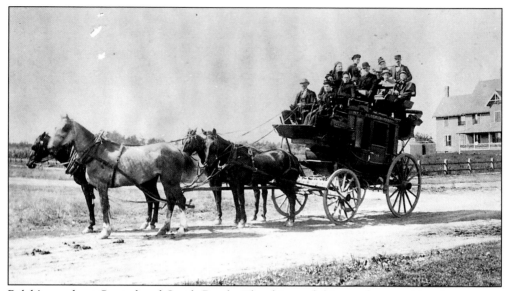

Balch's coach at Central and South Roads. The driver of this coach was said to be a mean-tempered coachman who in one notorious incident actually stopped and killed a misbehaving horse with a hammer in front of his passengers and then unhitched the dead beast and proceeded on to Portsmouth.

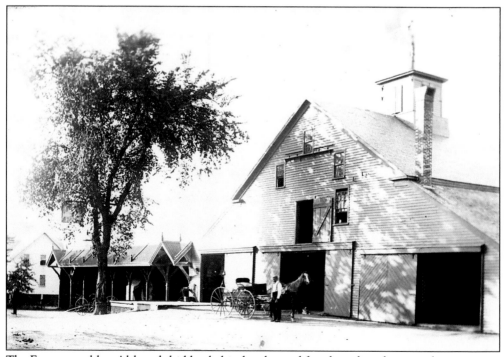

The Farragut stables. Although hidden behind a plywood facade and used to store lawnmowers, these buildings survived until the very end.

Four

Churches and Schools

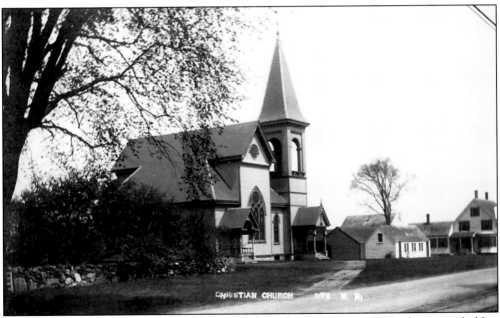

CHRISTIAN CHURCH RYE, N. H.

The "Brown Church" united with the Congregational church in 1945. The last event held at the "Brown Church" was a summer fair, the crowning glory of which was a Mother Goose village that was handmade by the Collins sisters and covered the entire altar. That Christmas it was the centerpiece of the "Enchanted Village" at the Jordan Marsh store in Boston. A former minister at the "Brown Church," the Reverend George Fox, was one of four chaplains lost when the SS *Dorchester* was sunk during World War II.

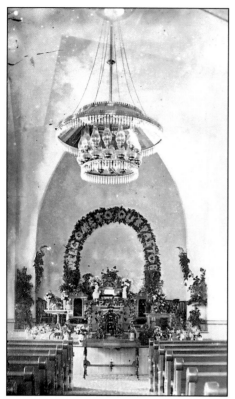

The interior of the new "Brown Church" in 1890. It was decorated to welcome the new pastor, Reverend Everingham.

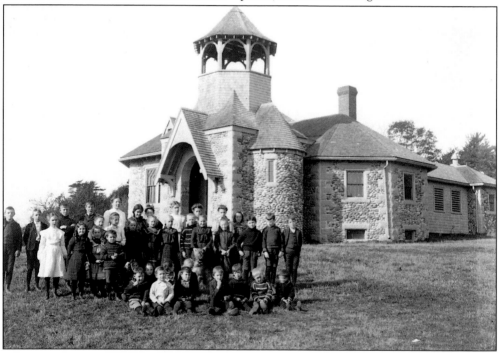

The East School *c.* 1900. Mrs. Ethel Philbrick is the teacher. This former school building is now a residence, but it no longer has the cupola shown in this photograph.

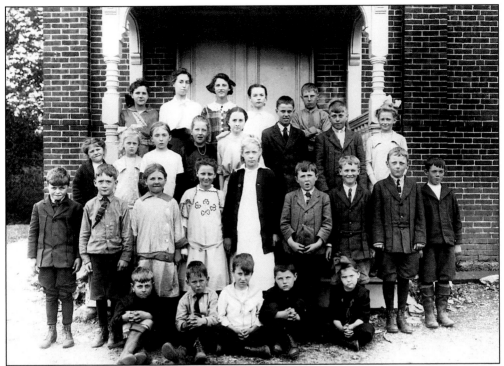

Pupils of the South School, *c.* 1916. Third from the left in the third row is Betty White Green, who has for many years acted as the Rye representative to the state legislature.

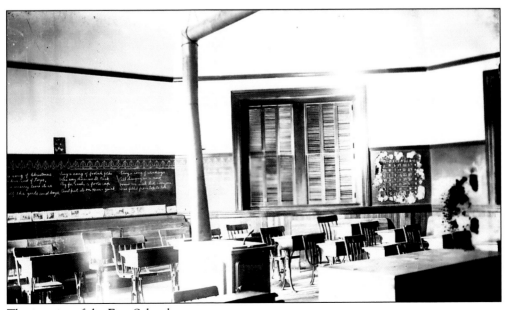

The interior of the East School.

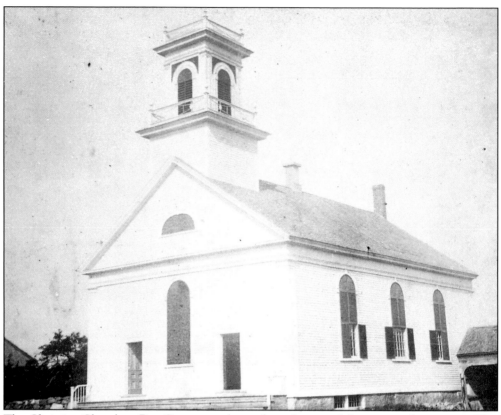

The Christian Church at Rye Center was located on the site of the current fire station. This 1839 building burned on February 19, 1888, as a result of an overheated furnace. It was replaced by the gothic "Brown Church."

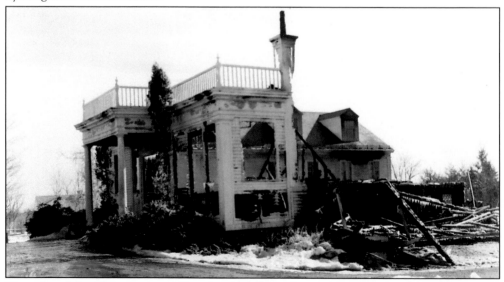

The ruins of the Congregational Church, which burned as a result of an overheated furnace in 1959. Although this building was lost, heroic efforts saved the parish hall that had been completed in 1957.

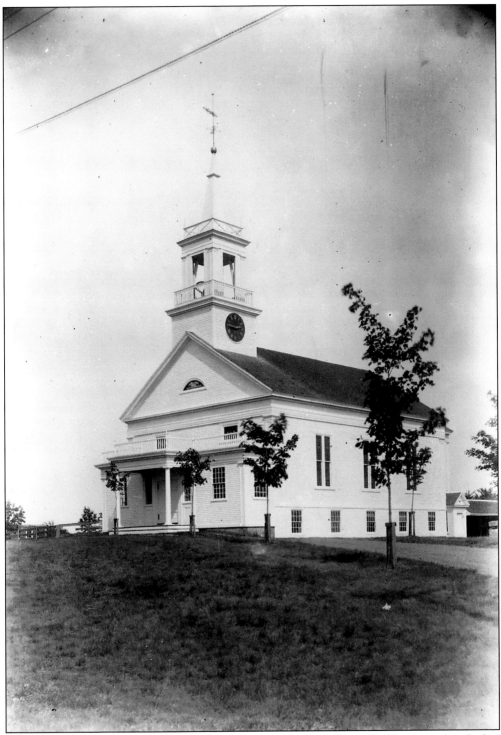

The "White Church," so-called to differentiate it from the gothic-style Christian church that was originally painted brown. This building, later to become the united Congregational-Christian Church, burned in 1959.

The Rye Beach residence of Charlie Spear, a well-known storekeeper, painter, and bandmaster. The small building with the gambrel roof later became the Rye Beach telephone office.

A late-nineteenth-century photograph of Charlie Spear.

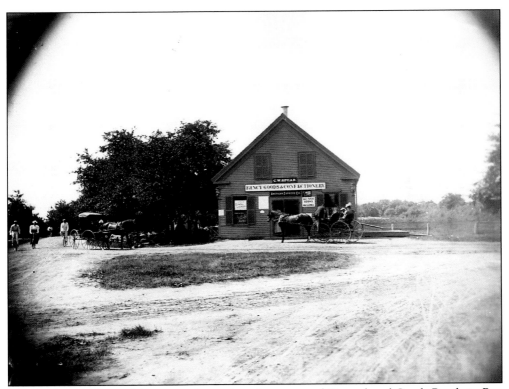

Charlie Spear's General Store was located at the corner of Central and South Roads in Rye Beach. Originally built as Biggin's Saloon, it was later moved to Sea Road and converted to the summer home of Miss Edith Hoyt.

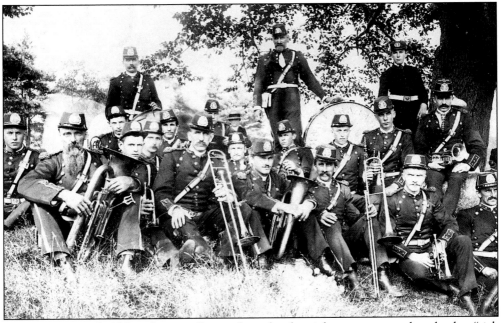

Spear's Brass Band. Although generally popular at local socials, one reporter thought that "sick elephants would sound more delightful" after hearing one rehearsal.

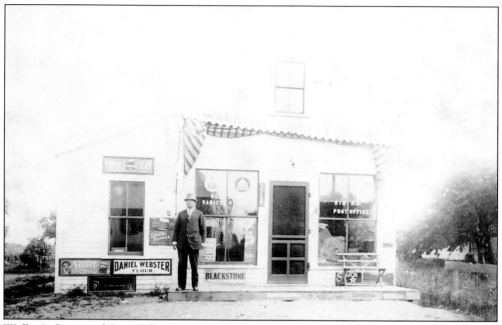

Walker's Store and Post Office at Rye Center. It became Jenness' Store when Iona Walker married Irving Jenness.

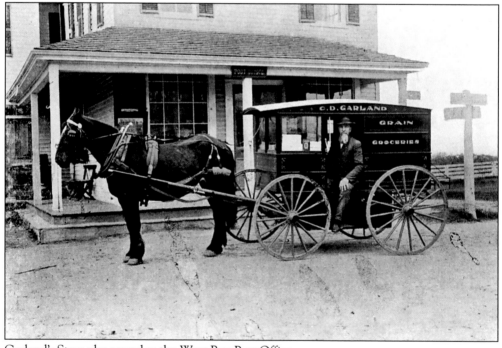

Garland's Store also served as the West Rye Post Office.

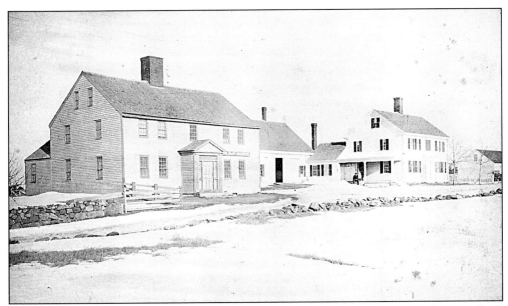

Neil Philbrick inherited this house and grocery store from his father-in-law, E.C. Jenness. Even as late as 1950, the interior had not been altered for nearly a century. In the 1940s Neil had a relatively new delivery truck with old-fashioned roll-up curtains on the sides. The truck was always immaculately clean, but he never seemed to have much of a load.

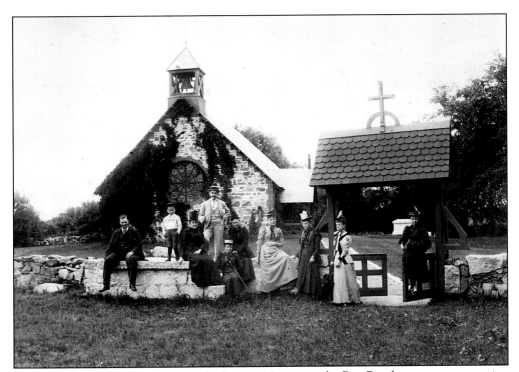

St. Andrew's Episcopal Church was built in 1876 to serve the Rye Beach summer community. The land was donated by the Philbrick family (builders of the Farragut Hotel), and some members of the family are buried in the churchyard.

RYE BEACH,

Which has come to be deservedly one of the most popular summer resorts in New England. The unfortunate destruction by fire, this spring, of the magnificent Ocean House, owned by Job Jenness, called the finest shore hotel in the country, will make quarters at the remaining houses even more desirable and difficult to secure this summer than last, when frequently the visitor would find not a room vacant on his arrival, and was glad to be quartered over night in some neighboring farm-house till the departure of some guest in the morning put a room at his disposal. The Farragut and Sea View Houses are the largest of the remaining hotels, the former being, in fact, a double hotel, the Atlantic which stands near it being under the same management, and having by degrees been joined to it by small houses nearly filling the interval, in which some of the most desirable rooms are located. The proprietress, Mrs. Philbrick, has not allowed its name nor its excellence to decline since the death of her husband, its founder, and it never was more prosperous than now. The location is charming, in a willow grove near the water's edge, at the southern end of the long beach. The beach is world famous for its hardness, smoothness, gentle slope and splendid drive of several miles. Here each day during the season the fashion and wealth of the great cities can be seen in the water; merchants, matrons, heiresses, professional men, and children all clad in those *outre* garbs which fashion sanctions as bathing dresses, but which give such a comical appearance to everybody—and all splashing and dripping like Tritons or mermaids. The hops at the Farragut, occurring weekly, are one of the most delightful features of life at this celebrated resort. The Sea View House, a new and very attractive hotel, with an immense piazza and a perfect hall of a cupola, is located on a considerable elevation half a mile inland from the Farragut. It is beautifully located and well-managed by George G. Lougee, and has been highly popular since its opening. The Surf House, a neat, quiet and comfortable family hotel is located near the site of the late Ocean House, two miles further up the beach, and receives its share of favor, under the management of Mr. Philbrook. Beyond North Hampton, the next station is Greenland, fifty-one miles from Boston, population 800, a farming town which we rapidly pass and soon arrive in

PORTSMOUTH,

A description of Rye from an 1873 tourist guide.

66

Five
Places that Touch Rye

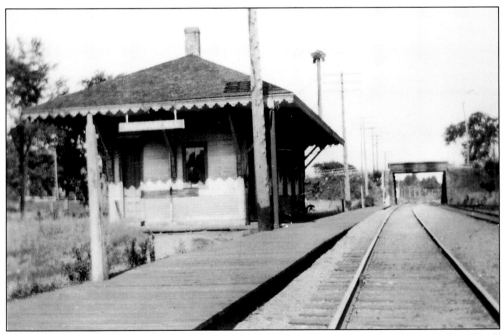

The Breakfast Hill railroad station in Greenland. Although tourists generally got off at North Hampton, this station was nearer Rye Center and was handy for farmers shipping goods such as apples and potatoes and picking up major items such as stoves ordered from the Sears, Roebuck, and Company catalog. A number of times, the Myopia Hunt Club brought their horses here by rail for a hunt through town. (Photograph courtesy of the Walker Transportation Collection, Beverly Historical Society)

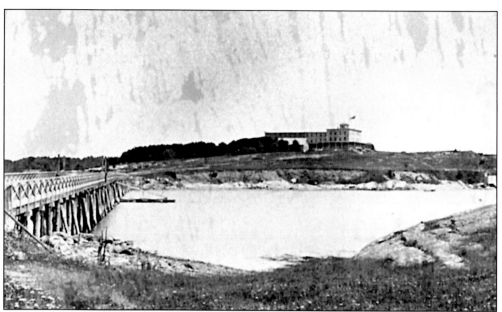

The building of the Wentworth Hotel in 1873 resulted in this bridge connecting Rye and New Castle.

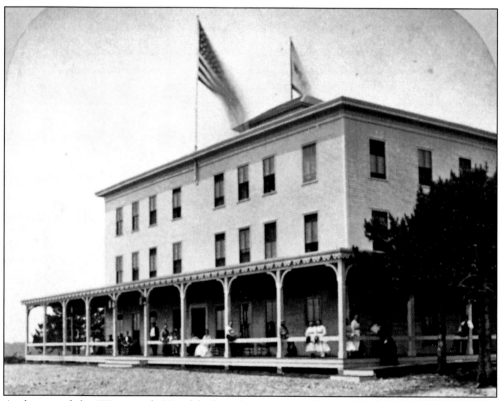

A closeup of the Wentworth Hotel before the towers and trim added by local businessman Frank Jones transformed it into a world-class resort. The Wentworth was first managed by a former prison warden, and then by Job Jenness in 1878 (after he was burned out in Rye).

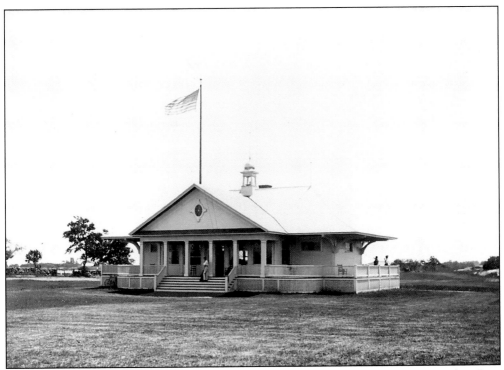

The golf course and clubhouse of the Wentworth Hotel. They were always located in Rye, despite the fact that the Hotel Wentworth is in New Castle.

The Tucke parsonnage on Star Island, which burned down in 1904. A Victorian visitor from Philadelphia refers to this house taking boarders about the time that Gosport village was annexed to Rye in 1876.

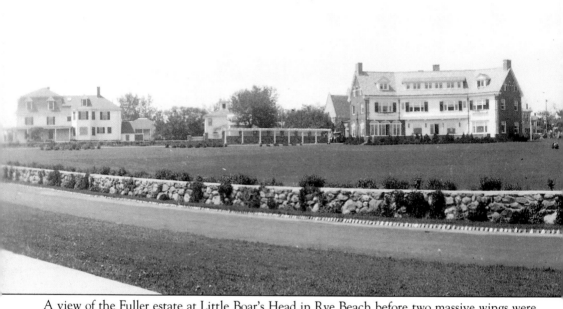

A view of the Fuller estate at Little Boar's Head in Rye Beach before two massive wings were added. This mansion was torn down in 1961. Although located in North Hampton, the nomenclature applied to Rye Beach has always indicated a social distinction rather than a distinct geographic area. On the left is the former cottage of President Franklin Pierce.

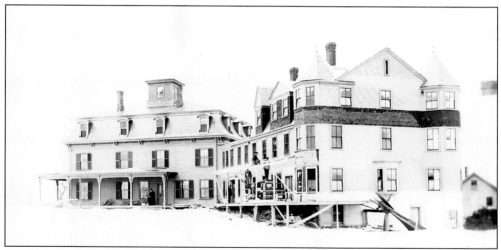

Seen here under construction, Batchelders's became the primary hotel at Little Boar's Head. It played host to many notables, including President Chester Arthur and frequent presidential candidate James C. Blaine.

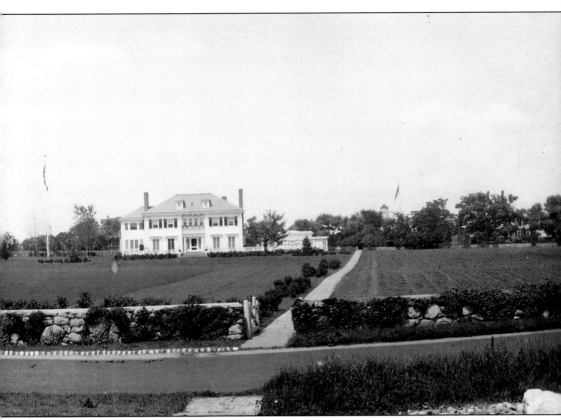

This house has welcomed many important guests: the memoirs of Hawthorne's son tell how he and the former president went skinny dipping here in 1864, and Senator Ross of Iowa came here as a summer guest to recover from a stroke he suffered during the impeachment trial of President Andrew Johnson.

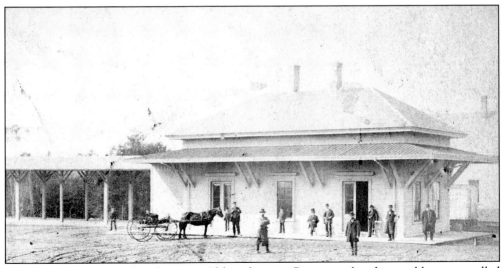

The North Hampton railroad station. Although not in Rye, on railroad timetables it was called the North Hampton (Rye Beach) station.

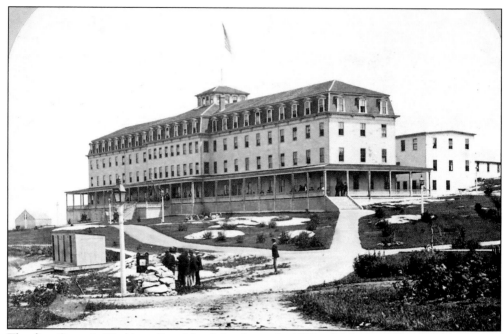

The first Oceanic Hotel on Star Island. In the early 1870s, the last residents of the town of Gosport on Star Island sold out to hotel interests and the southern three islands of the Isles of Shoals were annexed to the Town of Rye.

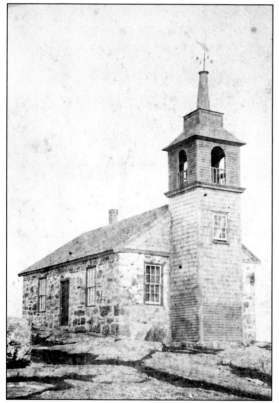

The Gosport village church on Star Island. The wooden tower seen here was blown down in a storm in 1892, and later rebuilt from stone. Over the years, many residents of Gosport had moved to the Sandy Beach area of Rye and built modest homes similar to the ones in which they had lived on the islands.

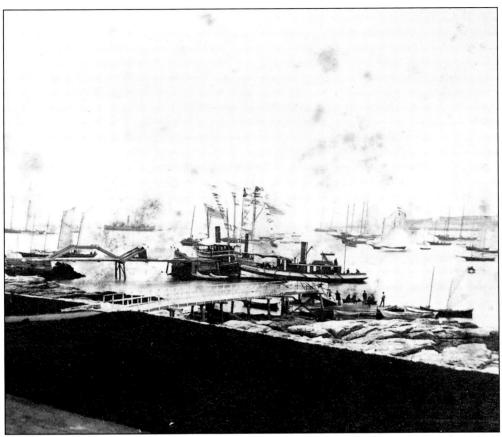

A regatta was held at Star Island to celebrate the opening of the first Oceanic Hotel in 1873. This gala event was attended by Civil War General Ben Butler with his yacht *America* for which the America's Cup races are named.

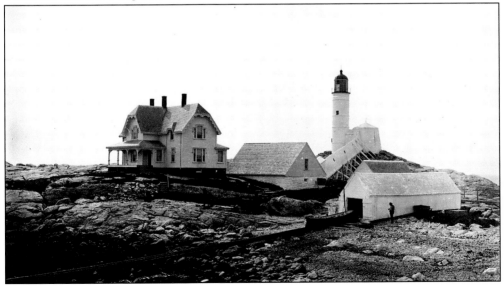

White Island Light on the Isles of Shoals.

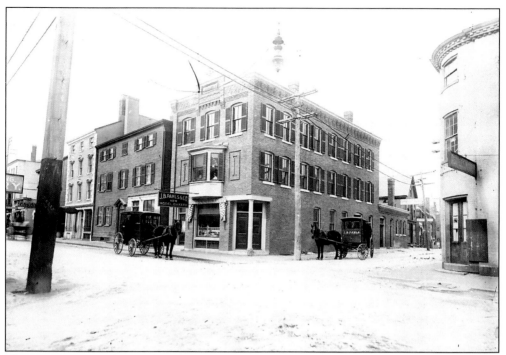

The intersection of Daniel and Penhallow Streets in Portsmouth. Portsmouth was the commercial center for Rye natives and tourists. Many Rye farmers went to Portsmouth several times a week to sell their produce.

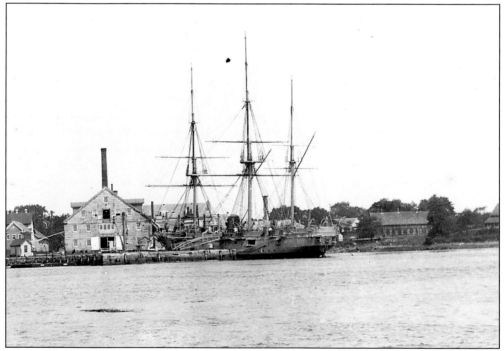

A must for all politicians and war heroes staying at Rye was a trip to the Portsmouth Naval Shipyard. Shown here is the USS *Essex*.

Six
Situations
by-the-Sea

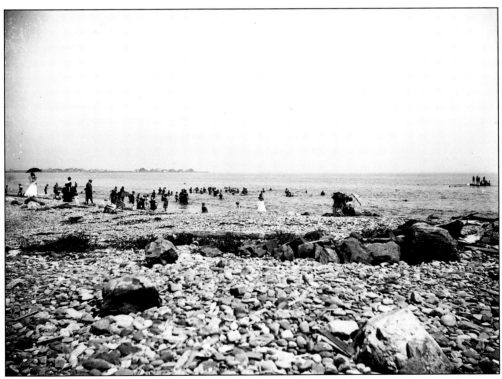

The bathing beach at Rye Beach. Early bathers, wearing long woolen suits and oilskin hats, are said to have been carried in the surf and slowly dipped in to lessen the shock of the cold water. The water temperature, seldom warm, was announced by blasts of a steam whistle at Locke's Bath House.

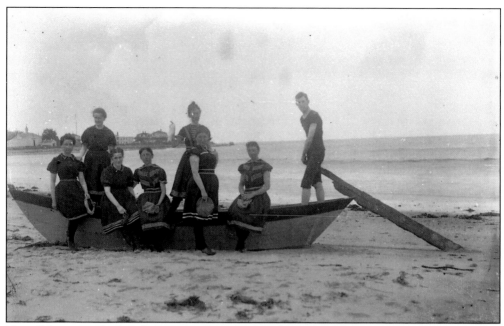

Not all boats on the beach were wrecks! This boatload of maidens is in front of the Jenness Beach Lifesaving Station.

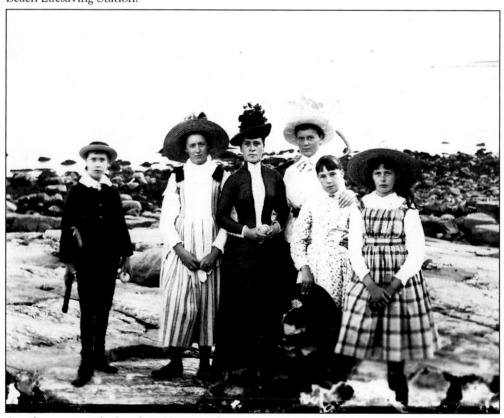

An afternoon on the beach in Victorian Rye never meant informal attire.

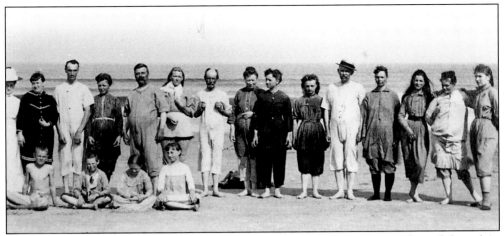

To quote a local Victorian reporter, "The Bible says that all men are created equal, but when dressed in bathing suits they sure don't look it."

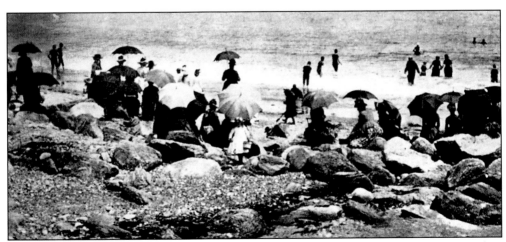

Watching the bathing ritual from the rocks. We can be certain that this picture was taken between the only socially acceptable bathing hours—eleven a.m. to noon.

Auctions.

PEREMPTORY SALE OF VALUABLE
REAL ESTATE
AND HOUSEHOLD FURNITURE.
For sale at Public Auction,
TUESDAY, Dec. 14th, at 11 o'clock, A. M.
On the premises,
SAGAMORE HOUSE,

ON Frost's Point, at the entrance of Little Harbor, 3½ miles by land, by water 2 miles, from Portsmouth. The House commands a view of Portsmouth, Newcastle, Kittery, the Navy Yard, Forts Constitution and M'Clary, Portsmouth Harbor and the Isles of Shoals. The outbuildings consist of a barn, corn house and bowling alley, all in good repair. The grounds contain 10 acres, bordering Little Harbor and the sea, and are well stocked with fruit trees. If more land is desired, it can be obtained on reasonable terms at private sale.

The facilities for sailing, fishing and bathing are unequalled, rendering it a desirable place for a private residence, a private boarding house, or a public house.

Terms at sale.

Also, all the Furniture in said House, consisting in part as follows, viz. :

4 Mahogany and Black Walnut SOFAS;
20 Mahogany Chairs; 60 Dining Chairs; 24 Office do.;
Chamber and Common do.; Chamber Setts;
Bureaus, 1 Settee, 1 Desk, 1 Hat Stand,
1 set Mahogany Dining Tables, Hard wood and Pine do.
Mahogany Card, Pembroke and Centre Tables,
8 large Dining Tables, 36 Looking Glasses,
26 Cottage and French Bedsteads, 10 Hair Mattresses,
Palm Leaf and Husk do., Feather Beds, Under Beds,
Bedding, Table Linen, Toilet Stands and Dress Tables,
17 All-Wool Carpets, Stair Carpets, Time Pieces,
Spy Glasses, Entry and Centre Lamps, Show Cases,
Pencil, Painted, Muslin and Damask Window Curtains,
Curtain Fixtures, Basins and Ewers, Table Cutlery,
Silver-Plated Ware, 1000 qts. and pts. Champagne Bottles, 2000 Porter and Ale Bottles, 3 Guns.
Ice Chests, Stoves, Dry Sinks, 2 Tool Chests,
Lot Tools, a variety of Crockery and Glass Ware,
Together with a great variety of articles too numerous to mention.

Also, 15 tons prime Pressed HAY, 500 bottles Cider, 5 Shoats, 2 Hogs, 11 Pigs, 1 Cow, 3 Calves, 8 tons loose Hay, 1 Chaise, 1 Wagon, 1 Job Wagon, 1 Sleigh, Harnesses, Farming Utensils, Manure, Geese, Poultry, &c.

Also, 1 Sloop Boat, 1 Wherry, 1 Punt.

RYE, N. H. Dec. 4th, 1858. GEO. W. TOWLE.

An advertisement for the liquidation sale of the contents of the first Sagamore House.

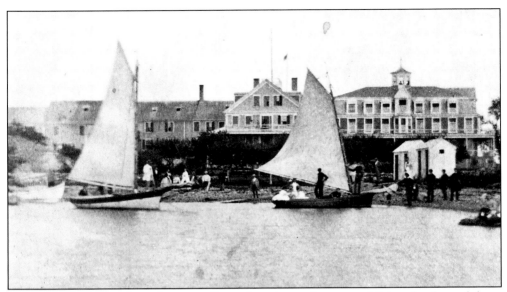

The Sagamore House from the water. Since this picture shows an addition that burned down after one year, it has to have been taken in 1870. From the activity shown here, it is obvious that the Sagamore House was not a retreat for invalids. (Photograph by Davis Bros., courtesy of the Society for the Preservation of New England Antiquities)

Sagamore House gatherings frequently featured great banquets served under tents and a brass band to keep things lively. After being burned out here, James Pierce ran the Imperial Hotel, formerly the Jenness House, on Pennsylvania Avenue in Washington, DC.

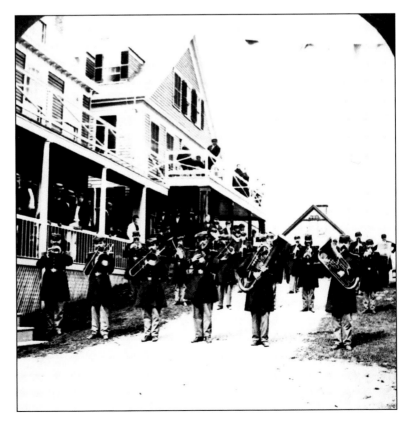

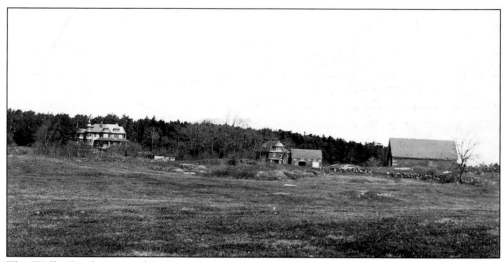

The Wallis Sands estate of Professor James Parsons. Professor Parsons was a professor of law at the University of Pennslyvania. The daughter of the summer doctor called to the estate to treat a patient recalls the family's opulent surroundings in her autobiography *Lively Days,* with memories of fast horses and coachmen, butlers, and champagne. Built in 1889, the estate burned in March 1934.

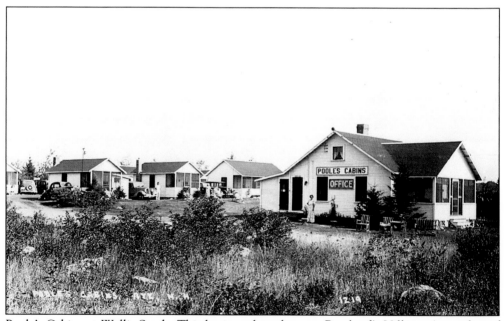

Poole's Cabins at Wallis Sands. This business later became Berglund's Village. A number of cabin colonies at Wallis Sands were moved to the site of the former Ocean Wave Hotel in 1963 to make room for the parking lot at Wallis Sands State Beach.

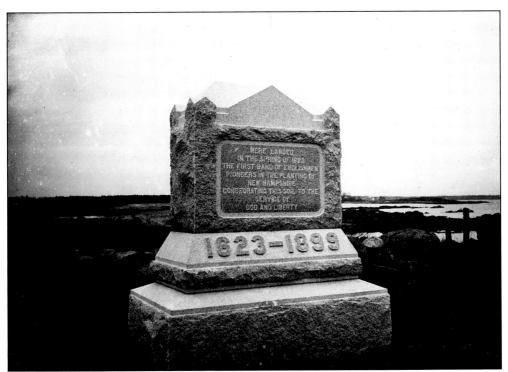

The monument commemorating the first European settlement in New Hampshire. First planned in 1873 as a major attraction that could be seen by all ships passing at sea, this was New Hampshire's answer to the monuments at Plymouth and Provincetown.

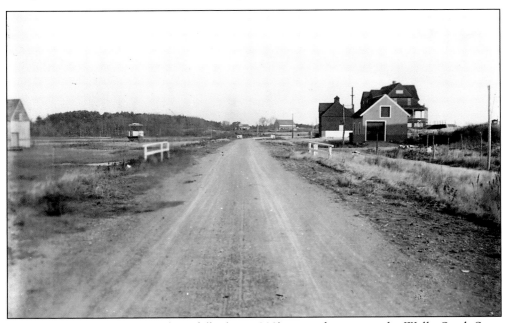

A view of the new Ocean Boulevard (built in 1900), near what is now the Wallis Sands State Park parking lot. The barn at the Parsons estate can be seen in the background. On the right is the house that became the Orcut Cottage.

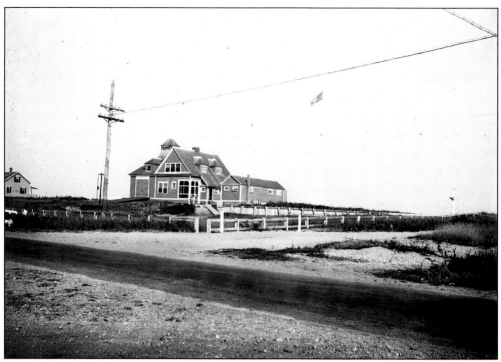

Wallis Sands Lifesaving Station was built in 1890 and closed in 1938. It was torn down after World War II and the Wallis Sands Restaurant built on its foundations.

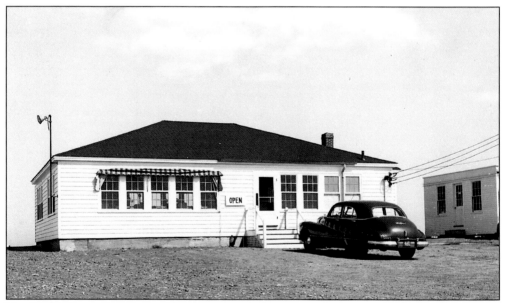

The Wallis Sands Restaurant. The strong seawall for the lifesaving station can still be seen in front of the restaurant. The popular local restaurant The Pirate's Cove now occupies this site.

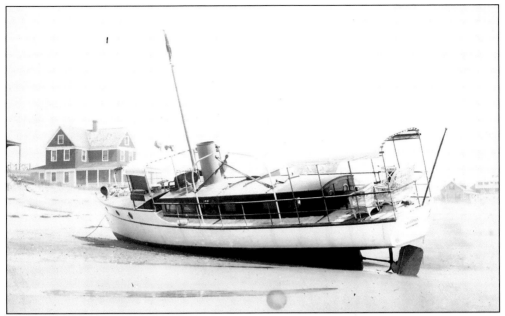

This steam yacht conveniently went ashore right in front of the Wallis Sands Lifesaving Station.

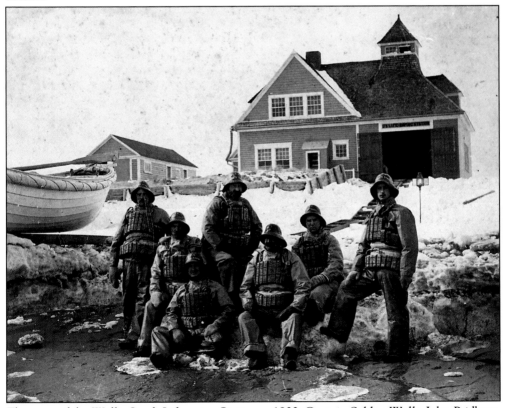

The crew of the Wallis Sands Lifesaving Station c. 1900. Captain Selden Wells, John Pridham, Horace Berry, Ben Ricker, and Thomas Varrell have been identified.

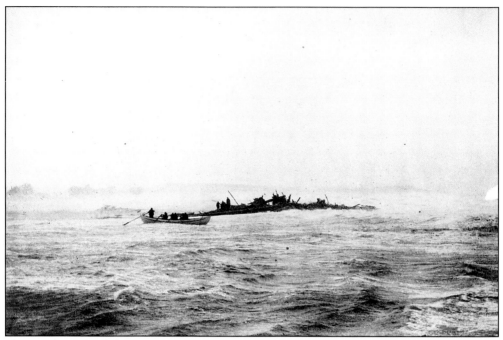

The 1905 wreck of the *Lizzie Carr* off Concord Point, with a dramatic rescue by the Wallis Sands crew in progress. The first mate drowned in the attempt but six crewmen were rescued.

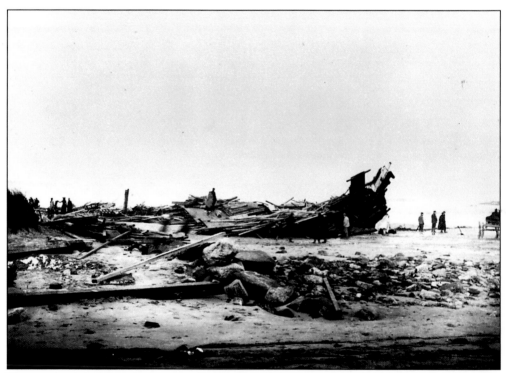

The wreck of the *Lizzie Carr* on the beach. The two-masted schooner had been transporting a cargo of building lathes between Calais, Maine, and New York City.

A shipwreck off Concord Point. It is probably the lime schooner *Victor* that burned and sank here in 1882.

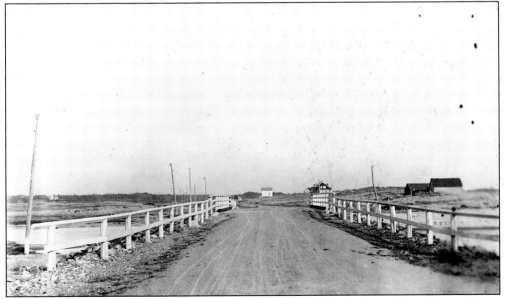

The new Ocean Boulevard just north of Concord Point. The sheds on the right are Ocean Wave Hotel bath houses.

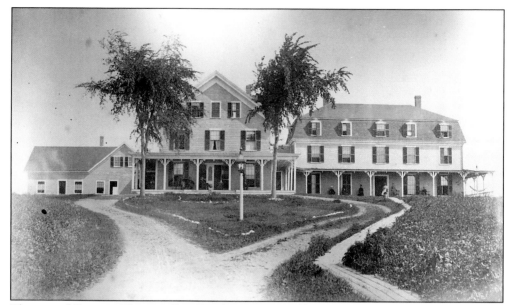

The second Prospect House at Foss Beach was operated by Civil War veteran Daniel M. Foss. The hotel was struck by lightning and burnt down on June 26, 1890.

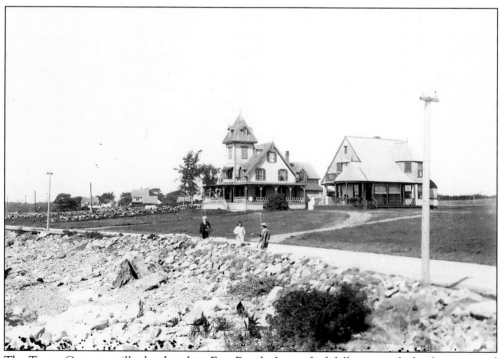

The Tower Cottage, still a landmark at Foss Beach. It was faithfully restored after being gutted by fire in March 1975.

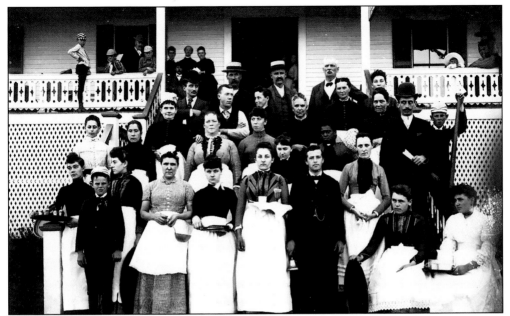

Employees of the Ocean Wave Hotel *c.* 1890. Their employer, Henry Knox (hatless in the back row), has obviously gathered them together for this photograph to be taken, and many are holding a symbol to represent their responsibilities.

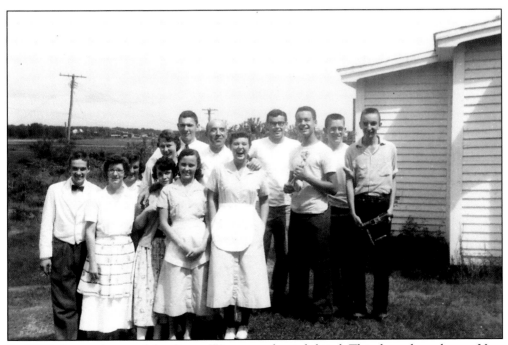

By 1956, the employees of the Ocean Wave were less inhibited. This shows housekeeper Vera Rand, Concord chef Louis Manias, and your author on the left in the back row.

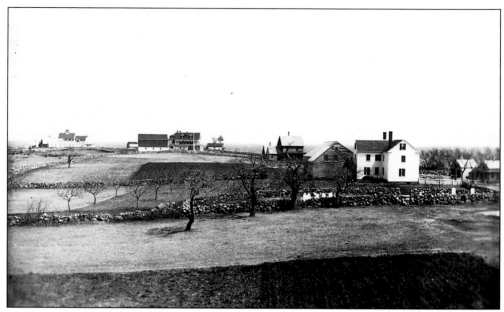

Buildings along Foss Beach. From left to right we can see the Ocean Wave Hotel, the second Prospect House of Daniel Morrison Foss, and Henry' D. Foss' white house and barn. The Foss family cemetery is in the foreground. This picture was taken prior to 1890 when the second Prospect House burned.

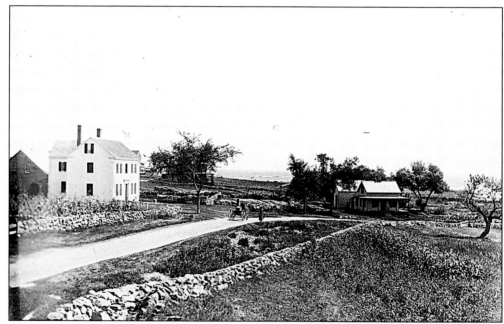

The hill at the ocean end of Washington Road. Foss' photography studio was just to the left of the frame of this photograph.

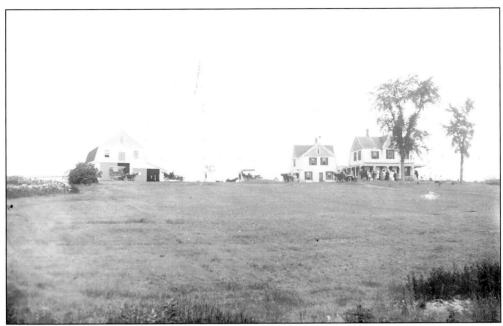

The still familiar "Windy Hill" at Foss Beach, site of two Prospect Houses that were struck by lightning and burned.

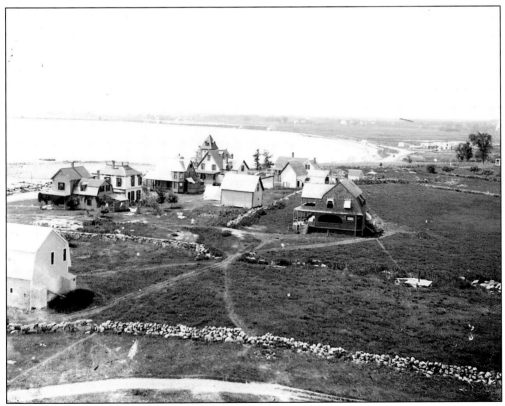

Looking south from the cupola of the Ocean Wave hotel.

Locals at Foss Beach. The photographer's sister, Minette, a piano teacher and organist, is in the middle of the back row.

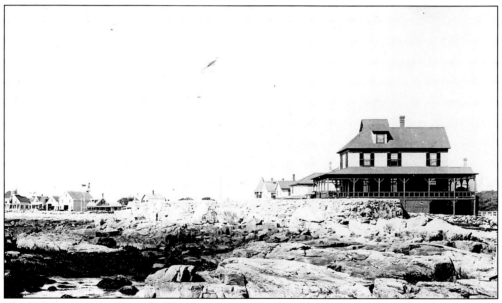

The Robie cottage at the end of Concord Point. This local landmark, also used as a barracks and observation lookout during World War II, was so trashed that it had to be torn down immediately after the war.

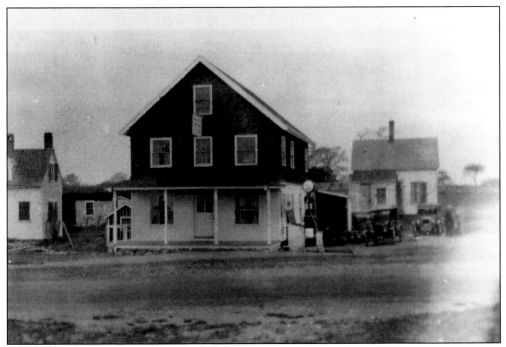

Orie Varrell's Chowder House and gas station at Washington Road and Ocean Boulevard. This restaurant was updated as Nick's Ocean View Grill and later as Rye-on-the-Rocks.

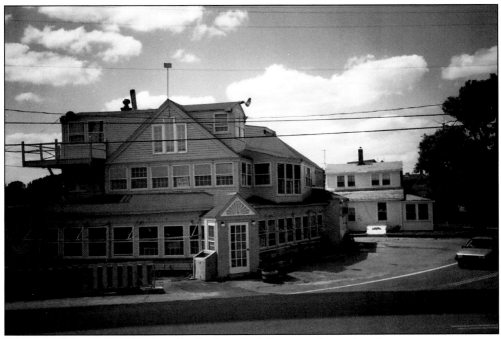

A recent photograph of Rye-on-the-Rocks, which has since been closed.

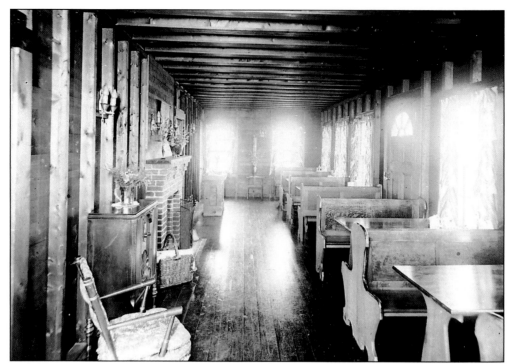

The Salty Breeze Restaurant was built in the 1930s by Newell Marden and Roscoe Berry for Roscoe's daughter Doris.

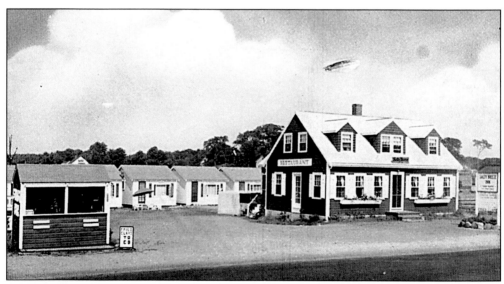

The Salty Breeze Restaurant was later operated by Mr. and Mrs. Lou Orgera as the Salty Breeze Motel, Cabins, and Snack Bar.

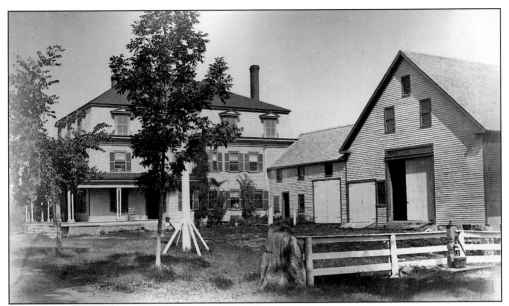

John Hunt Foss' boarding house Pleasant View burned in 1890 under mysterious circumstances. When neighbours went to save the furniture, they found the carpet tacks already conveniently removed from all the rugs. The house was located just west of Sylvanus Foss' on Washington Road.

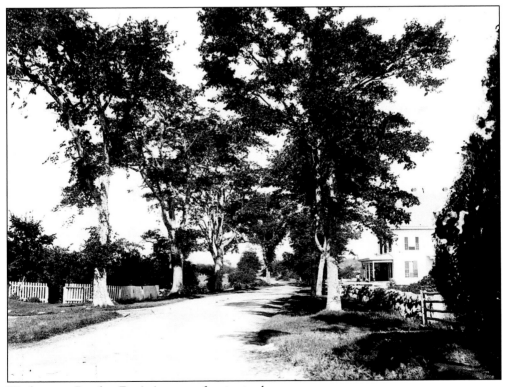

Washington Road at Foss'. A street of majestic elms.

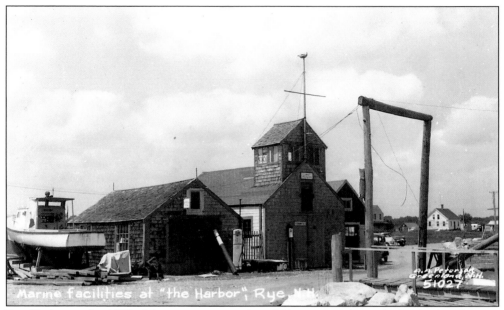

Rye Harbor in the 1950s. Most tourists miss this idyllic view at the end of a dead-end street. The tower was built by Police Chief Manning Remick as a volunteer lookout post after the lifesaving stations were closed in 1938.

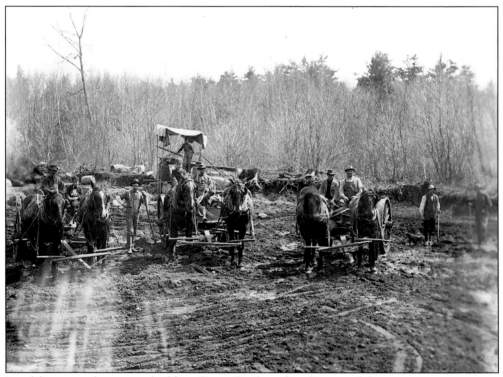

Local farmers and teamsters building Ocean Boulevard at the turn of the century.

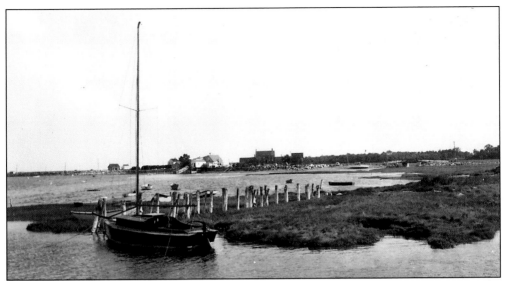

Rye Harbor before it was filled in 1960 to create a state pier and parking lot. Prior to the construction of the breakwater in 1938/9, Rye Harbor was not a busy place—except for the rum-runners. After federal agents shut down the fast speedboats that had been getting into the coves of Little Harbor and loading onto trucks that exited near Foye's Corner, the local modus operandi changed. The boats now dropped their load of liquor overboard, usually disguised as rocks in burlap sacks. A favorite drop-off point was under the wharf at Rye Harbor. In 1938, the saltmarsh on the inland side of the harbor was sold to the New Hampshire National Guard as the site of an airfield, but aviation advanced too fast during the war years and Rye never got its airport. In the foreground of this photograph is a sailboat belonging to John Blanchard. In the 1940s he had the adventure of an around-the-world cruise with Gloucester's Captain Irving Johnson.

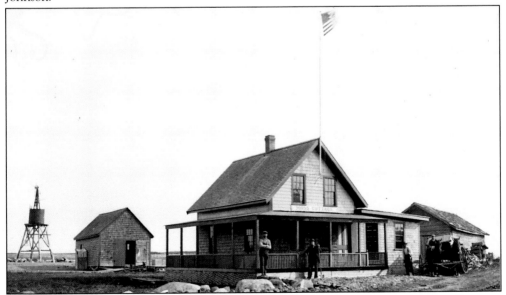

The Moss Cottage at Rye Harbor. This was the Rye branch of a company based in Scituate, Massachusetts, that collected and sold Irish sea moss that was used in the making of gelatin desserts and for filtering ale. This building later became Saunder's Lobster House.

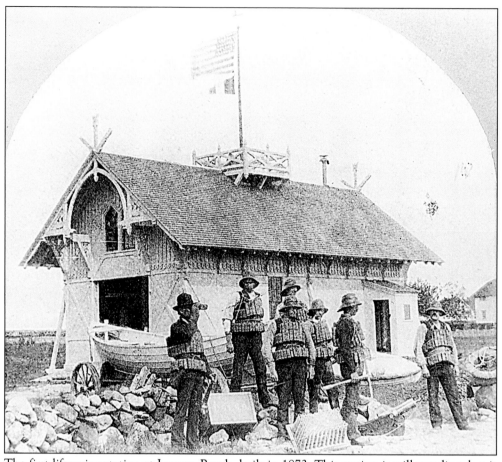

The first lifesaving station at Jenness Beach, built in 1873. This station is still standing, but it has been converted to a summer cottage. (Courtesy of the Rye Historical Society)

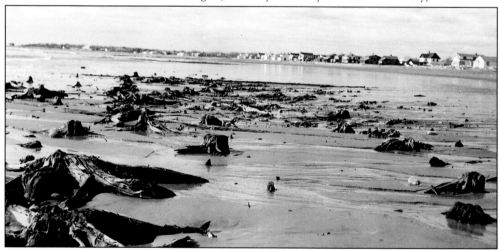

This sunken forest at Jenness Beach has only come out of the sand a few times in the last one hundred years. The original Atlantic cable can be seen running horizontally through the center of the stumps.

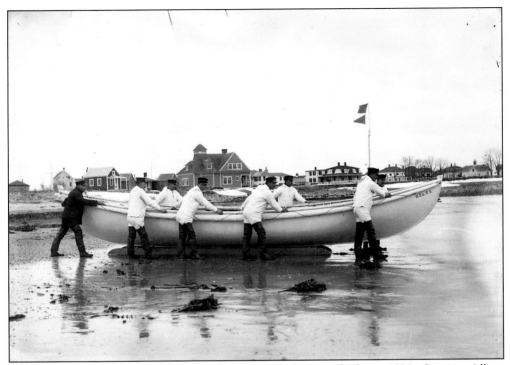

The crew of the second Jenness Beach Lifesaving Station, built in 1890. Captain Albert Remick is at the stern.

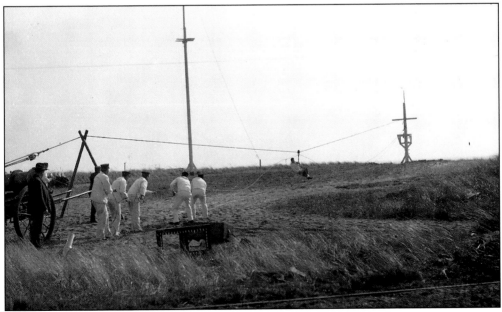

Local lifesavers practicing with the breeches buoy.

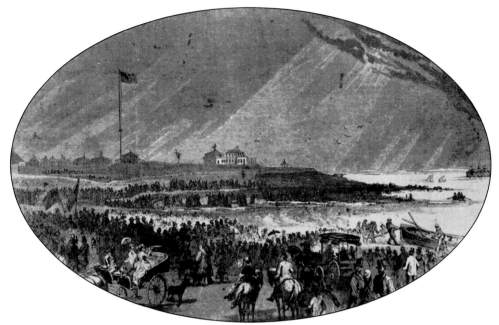

An engraving made to celebrate the landing of the first direct ocean telecommunications cable between Europe and the United States. It landed at Straw's Point on June 27, 1874. Earlier cables from Europe had come overland from Nova Scotia.

The second office of the US Direct Cable Company at Jenness Beach. Rye resident Cyrus Eastman (who at different times owned the President Pierce cottage and an Odiorne Point estate) arranged the European financing for the project.

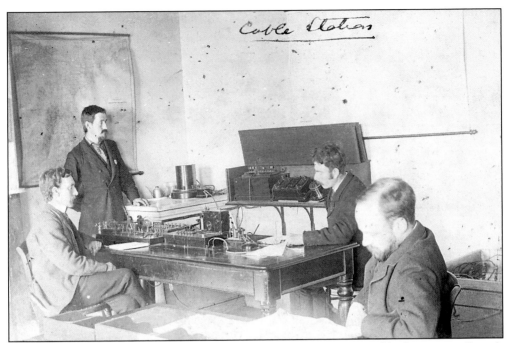

The English crew and their equipment at the office of the US Direct Cable Company at Straw's Point. (Courtesy of the Rye Historical Society)

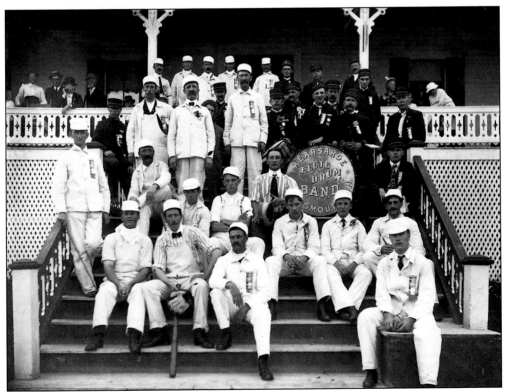

A Portsmouth gathering at the Ocean Wave Hotel in the 1880s.

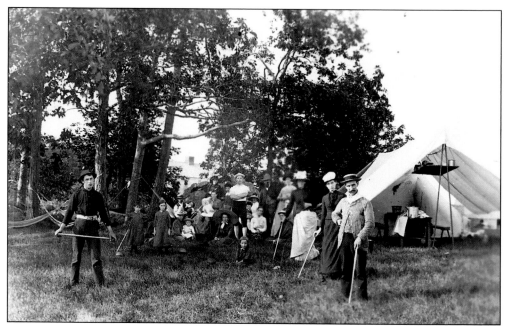

An 1880s camp at Rye, possibly at Rand's Grove off Cable Road.

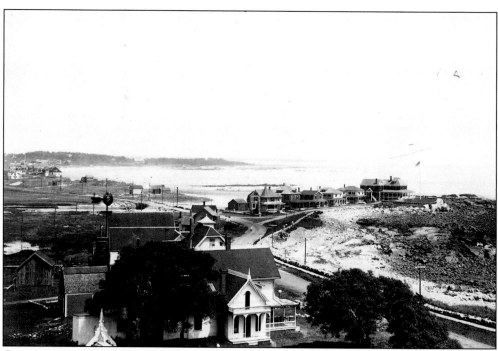

Cottages at Concord Point from the cupola of the Ocean Wave. This area was first developed by people from Concord, New Hampshire, who first came to Rye with Epson stagecoach driver Henry Knox, who later built the Ocean Wave.

Seven

Rye Beach

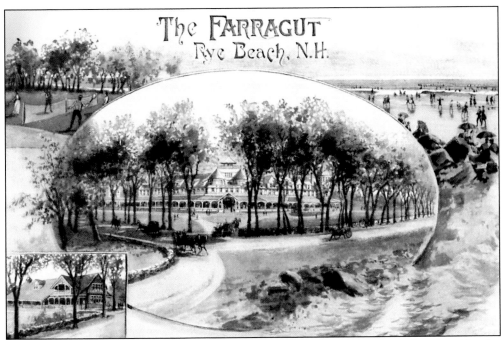

The Farragut was a first-class landmark at Rye Beach that slowly deteriorated as the old order died. After a disastrous final season, with weeds in the gardens and never more than fifty guests at one time, it was closed in 1974 and was torn down in 1975. Almost at once, a third Farragut filled the space but it was only ever completed on the outside. It has sat unfinished, an empty shell, for twenty years.

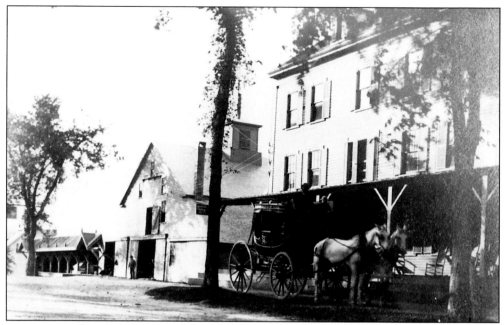

The Atlantic House and its stables. It was here that Admiral Farragut stayed for a week in 1865 while a big addition to his hotel was under construction. The addition opened as Philbricks', but by the following spring it had been renamed the Farragut.

Elder Ephraim Philbrick. Philbrick was captain of the local volunteers during the War of 1812 and a lay minister. He also built the Atlantic House, Rye's first hotel.

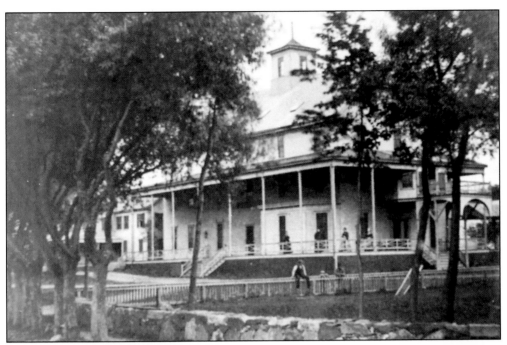

The first Farragut Hotel.

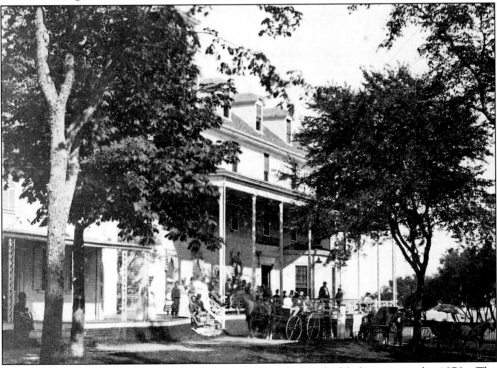

The success of the first Farragut Hotel resulted in its being doubled in size in the 1870s. The skylights were replaced by dormer windows, and rooms were built in the attic, to accommodate the flood of guests. Although offering great views, these fourth-floor guest rooms were often described as ovens under the eaves.

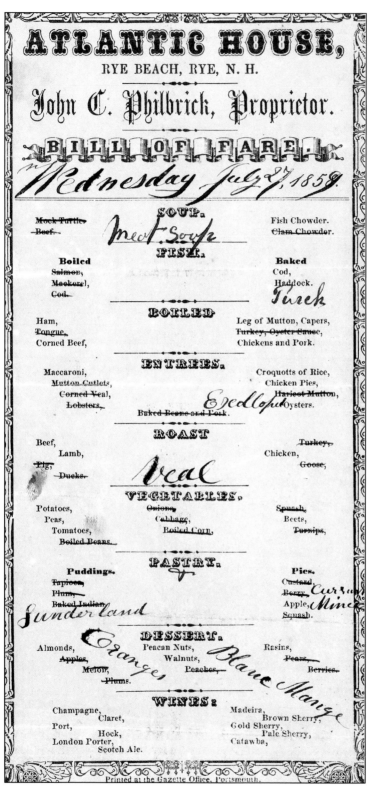

ATLANTIC HOUSE,

RYE BEACH, RYE, N. H.

John C. Philbrick, Proprietor.

BILL OF FARE.

Wednesday July 27, 1859

SOUP.

Mock Turtle, *Meat Soup* Fish Chowder.
Beef, Clam Chowder.

FISH.

Boiled	**Baked**
Salmon,	Cod,
Mackerel,	Haddock.
Cod.	*Tuck*

BOILED

Ham, Leg of Mutton, Capers,
Tongue, Turkey, Oyster Sauce,
Corned Beef, Chickens and Pork.

ENTREES.

Maccaroni, Croquetts of Rice,
Mutton Cutlets, Chicken Pies,
Corned Veal, *Scallops* Harico't Mutton,
Lobsters, Oysters.
 Baked Beans and Pork.

ROAST

Beef, Turkey,
Lamb, *Veal* Chicken, Goose,
Pig,
Ducks.

VEGETABLES.

Potatoes, Onions, Squash,
Peas, Cabbage, Beets,
Tomatoes, Boiled Corn, Turnips,
Boiled Beans.

PASTRY.

Puddings.	**Pies.**
Tapioca,	Custard,
Plum,	Berry, *Currant*
Baked Indian	Apple, *Mince*
Sunderland	Squash.

DESSERT.

Almonds, *Oranges* Peacan Nuts, *Blanc Mange* Rasins,
Apples, Walnuts, Pears,
Melon, Peaches, Berries.
Plums.

WINES:

Champagne, Madeira,
 Claret, Brown Sherry,
Port, Gold Sherry,
 Hock, Pale Sherry,
London Porter, Catawba,
 Scotch Ale.

Printed at the Gazette Office, Portsmouth.

A menu from the Atlantic House. It indicates that wealthy summer visitors expected first-class fare even if some things weren't yet in season.

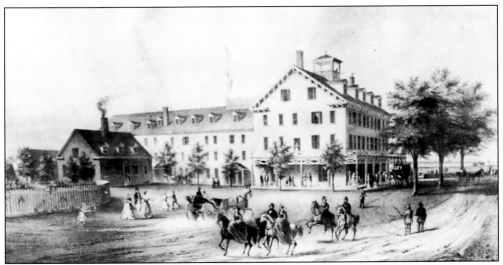

The first Ocean House from a lithograph. This hotel, operated by Job Jenness in 1848, catered to the early railroad traffic from as far south as Washington, DC. It was President Franklin Pierce's only headquarters during his 1852 presidential campaign, and he entertained Nathaniel Hawthorne here for lunch prior to Hawthorne's three-week vacation to the Isles of Shoals. This hotel burned on June 23, 1862.

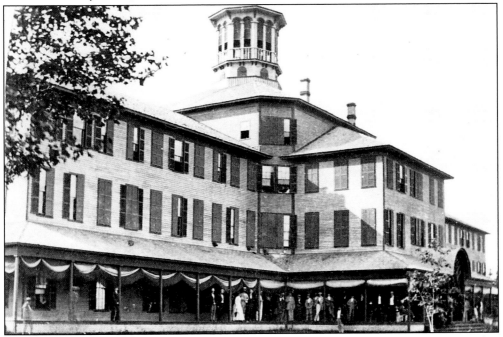

The second Ocean House. Designed by Newburyport architect Rufus Sargent, this was said to be the finest summer hotel on the East Coast. It was originally supposed to open in 1864, but completion was delayed because of the shortage of local labor during the Civil War. However, it was completed in time for the 1865 victory season and it very quickly became a national favorite. Mr. Jenness also operated the Jenness House in Washington, DC, and was familiar with most national politicians and their entourage. Like so many of its neighbors the Ocean House burnt (in 1872) and was not replaced.

A band concert at the second Ocean House. Although it never got the towers and bay windows illustrated in its advertising brochure, the magnificent rooftop observatory replaced the original box-like cupola. Unfortunately, this grand hotel burned when it was less than ten years old.

Job Jenness, owner-operator of the Ocean House. This native of Rye also operated the Wentworth, the Ocean Bluff House in Kennebunkport, Maine, the New Ottawa House in Portland Harbor, the Jenness House in Washington, DC, and the Webster House in Boston.

John Colby Philbrick, pioneer Rye hotel keeper. In addition to his hotels in Rye, he also built the Kearsarge Hotel in Portsmouth, originally called Philbrick's.

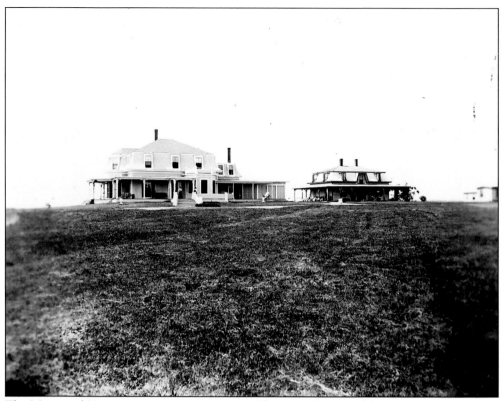

The Meigs and Huse cottages at Straw's Point. This area, developed by ex-governor Straw of New Hampshire, has recently reverted to its first name, Locke's Neck. It was originally named for John Locke, who was killed there by hostile Indians in 1696.

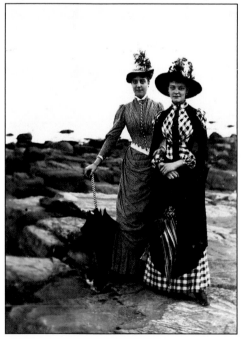

An old photograph album identifies the lady on the left as Edith Hoyt, the champion golfer, who owned a house on Sea Road converted from Spear's store. When showed the picture in the 1950s, she could not remember ever having seen a hat like that.

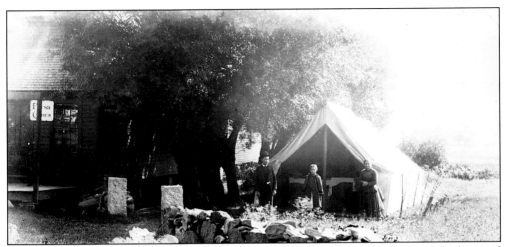

Gypsies at the Farragut Hotel. The Farragut gypsies, who made and sold sweetgrass baskets and other souvenirs, were a fixture at Rye Beach for many years. They were always remembered as a highly-regarded part of the community.

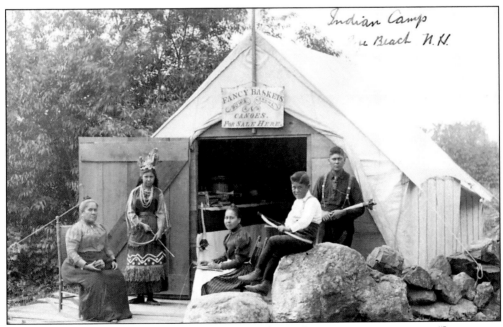

In later years, the gypsies passed as American Indians. One young tourist writes: "Just to step inside their tent was like going into an enchanted world." Rye Beach Brahmins who knew them admitted that the "Indians" were, in fact, part of the gypsy clan of Sylvanus Stanislaw. (Courtesy of the Rye Historical Society)

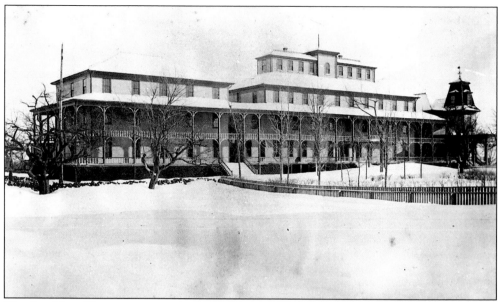

The Sea View House in winter. Located on the site of the current Catholic church, it was feeling its age by 1917 and was torn down. Although the building had an imposing facade and a dancehall built on rubber blocks, the only sea view was from the fourth-floor cupola.

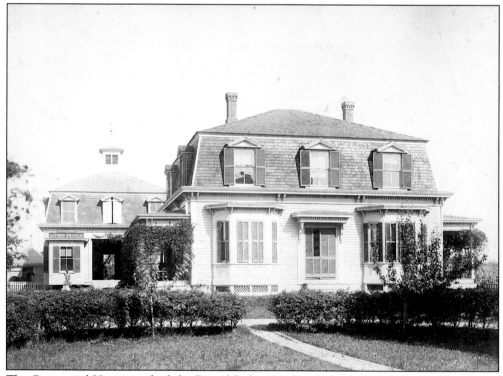

The Centennial House was built by Daniel Dalton in the centennial year of 1875 to replace a previous Dalton House that had burned. Located opposite the current post office, this building also burned, in 1901.

This image shows the Sea View House before the dance hall addition was built in 1873. Bathing suits dry on the porch rail, and Archie Jenness is selling spruce beer and ginger ale. The back wing was the service portion of the building that included the dining room, pool hall, barbershop, and privies on the first and second floors.

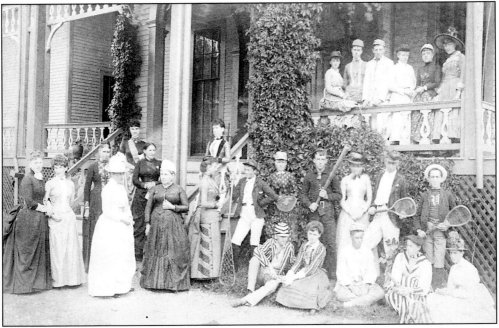

On the steps of the Sea View House. It is interesting to realize that although behavior and morals were important in the Victorian era, the high-class resorts included a lot of young people and youthful activities.

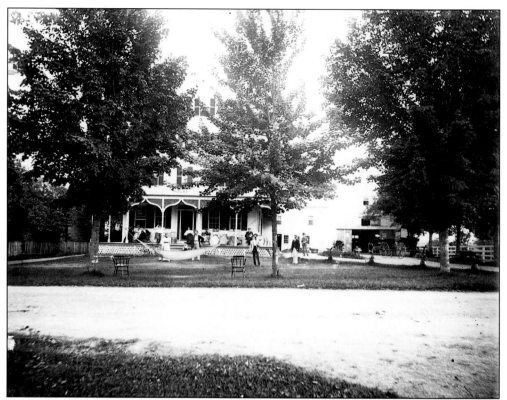

The Washington House on Cable Road. This hotel, located near the Ocean House, had a slightly less distinguished clientele. You could stay here for $3 per week, the same as it cost to stay a day at the Ocean House. This hotel lasted into the twentieth century, but burned in 1926.

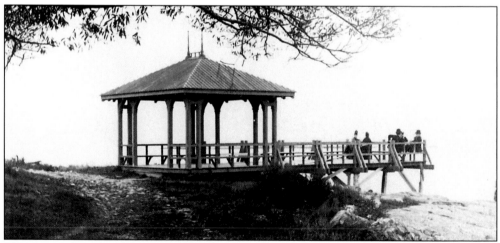

The summer house at the Farragut Hotel.

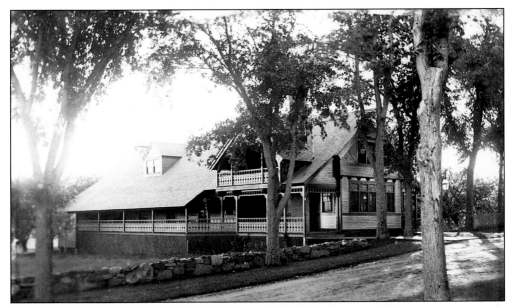

The casino at the Farragut Hotel. Built as the social hall for the second Farragut, it was mostly used as the hotel dancehall. In the 1940s and 1950s it also served as a first-run movie theatre open to the general public.

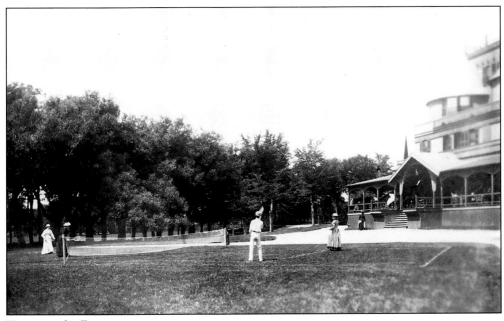

Tennis at the Farragut.

The plank walk that ran from the Farragut to St. Andrew's Church and the bathing beach.

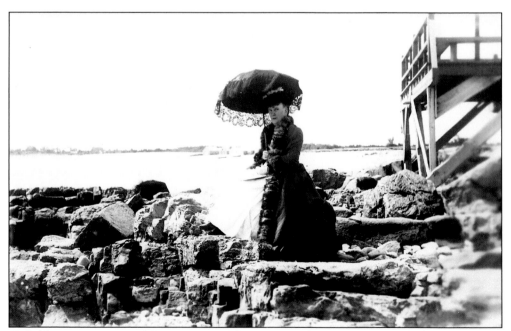

Probably not a very typical Farragut guest. She appears to be very eccentrically dressed even for the gay nineties.

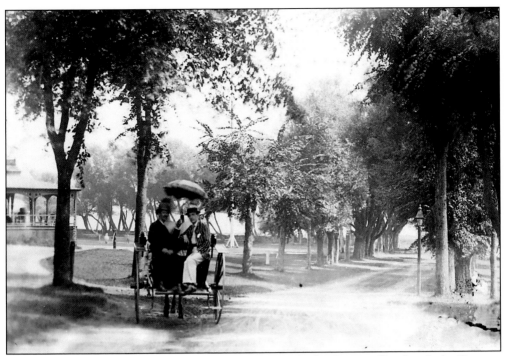

Young dandies of the gay nineties enjoying a ride outside the Farragut Hotel with the Farragut willows as a backdrop.

The first Farragut Hotel with the Abbotts' cottage in the background. The Abbotts were part of the famous Concord, New Hampshire, carriage-making firm of Abbott and Downing.

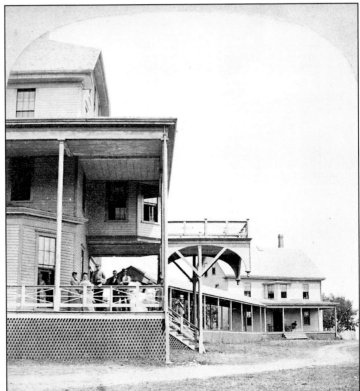

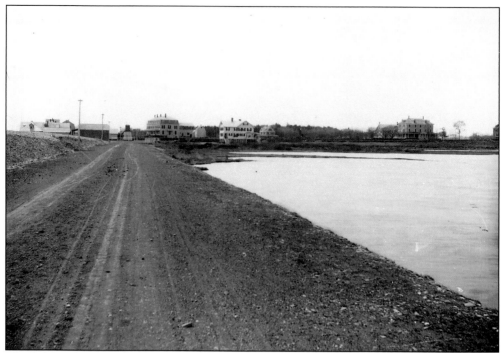

The Eel Pond. Originally a tidal pond, it was dammed *c.* 1800 and became a totally freshwater pond. In these two photographs we can make out (beginning with the top picture, from left to right) Sawyer's and Locke's Bath Houses, the Drake House, the Marden House, various boarding houses dating from 1875 onwards (when the road was laid out), and the estates on Red Mill Lane.

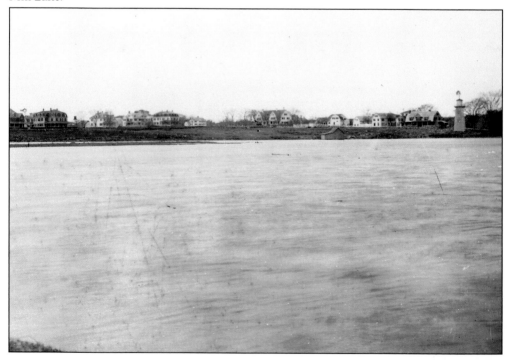

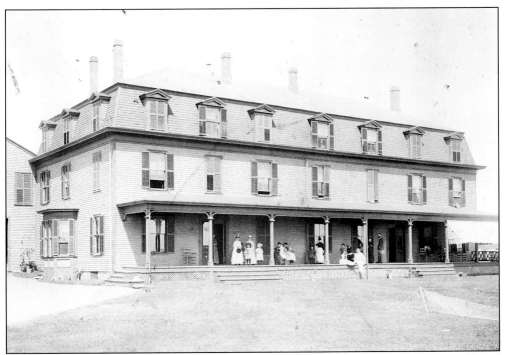

The Drake House. This hotel, still standing as condominiums, was built after the original hotel burned in 1873.

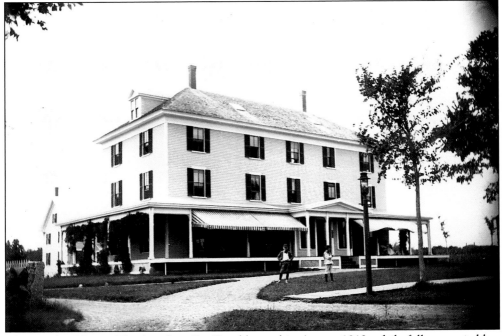

The Marden House. This hotel on Sea Road burned in August 1912, while fully occupied but quarantined due to a whooping cough epidemic. The fire started at the rear in the hotel garage, giving the guests time to pack their trunks and sit in the lobby with a fire in the fireplace until the building burned out of control.

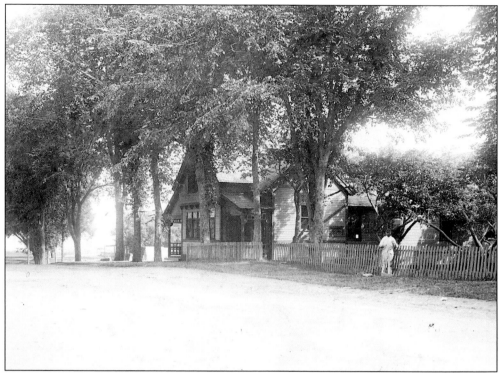

Painting the fence at the Farragut Casino. In the background is the porch of the bowling alley, later converted to a garage. The gypsies' tent can be seen under the street lamp in the center of the picture.

Hulda Salter, whose father owned the Farragut. She went to France as a volunteer ambulance driver during World War I. She is buried in the St. Andrew's church yard.

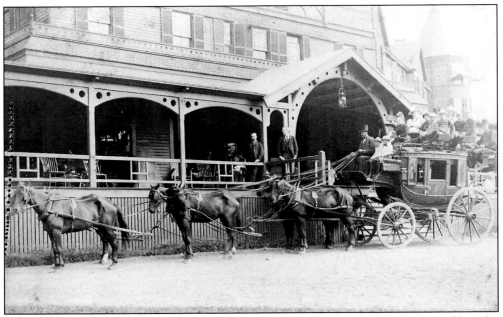

Balch's coach at the Farragut. It was said that his horses were so thin that you could read a newspaper through their sides.

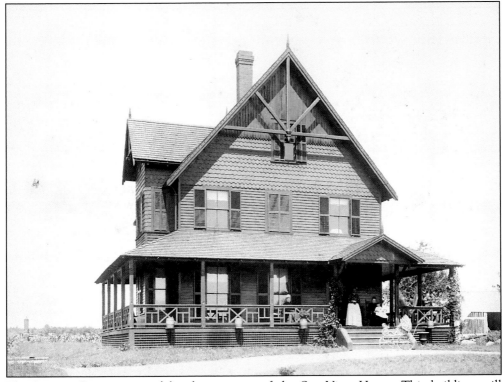

The Lougee Cottage, owned by the operator of the Sea View House. This building, still standing opposite the Rye Beach Post Office, is on the site of the Centennial House that had replaced, in turn, the Dalton House.

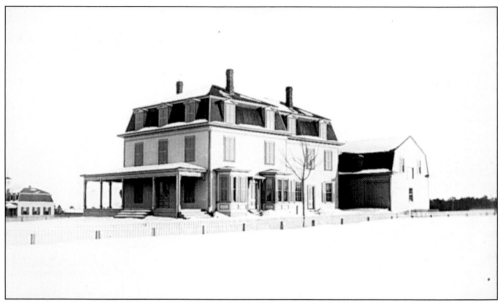

Locke's Boarding House, owned by the same family who owned the bath houses. This Victorian boarding house was later handsomely restored by Mrs. Edwin Armstrong.

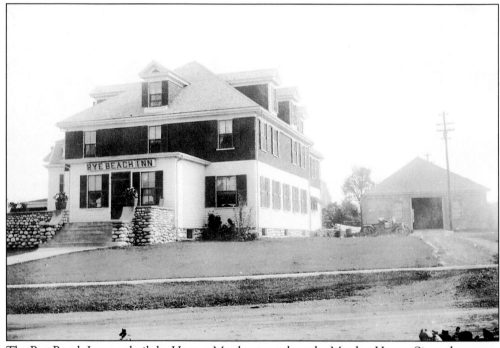

The Rye Beach Inn was built by Horton Marden to replace the Marden House. Since the garage remains, it is clear that this hotel sat on what is now the Drake House lawn. This building was later turned one hundred eighty degrees, moved one hundred yards up Sea Road, and remodeled as a summer home for E. Lansing Ray of St. Louis, one of the primary financial backers of Lindberg's historic flight to Paris.

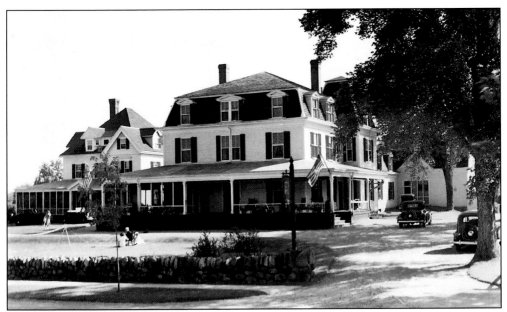

Sawyer's Boarding House. Although they operated one of the best boarding houses at Rye Beach, the owners invested heavily in the Stoneleigh debacle and lost everything. They went bankrupt and the bank tore down the building when it appeared that it might be used in a manner not befitting Rye Beach.

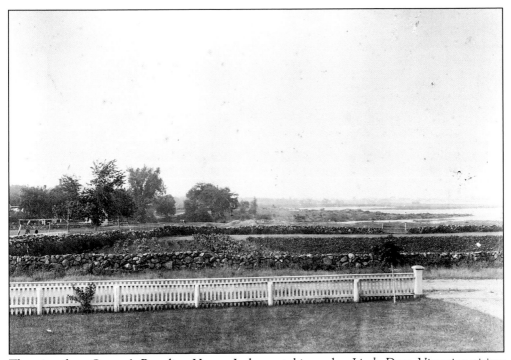

The view from Sawyer's Boarding House. In her autobiography, *Lively Days*, Victorian visitor Margaret Homer Schurcliff recalled, "since the path to the beach was through the cow pasture, I have always planned to go with the adults and give the cows a wide berth."

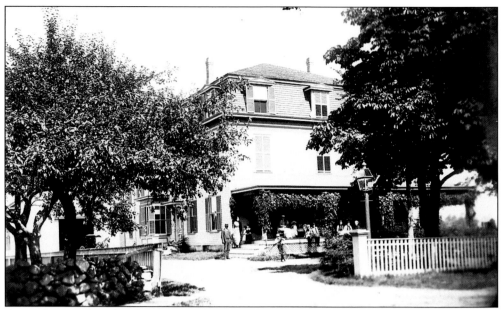

Austin Jenness' boarding house on Red Milk Lane. Also owned by Russell Sawyer, this building was lost through bankruptcy, re-acquired, and then torn down except for the kitchen wing.

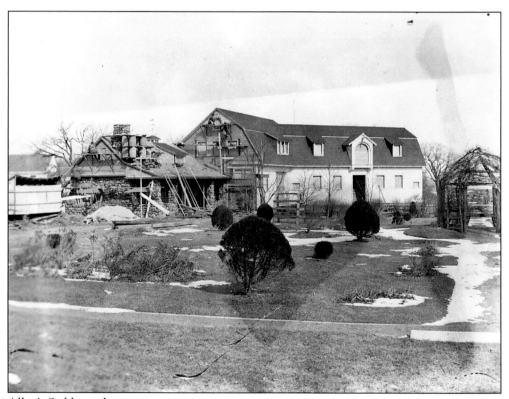

Allen's Stable, under construction.

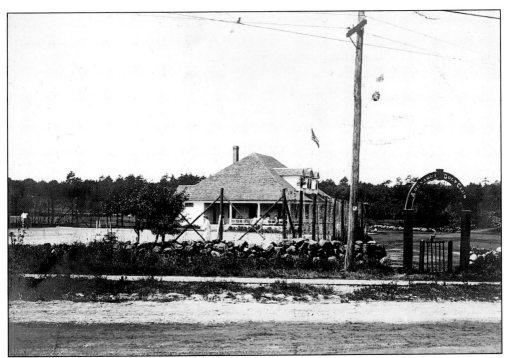

The Abenaqui Golf Club clubhouse. Originally built on the site of the current tennis courts in 1900, it was later moved to the opposite side of the fairways.

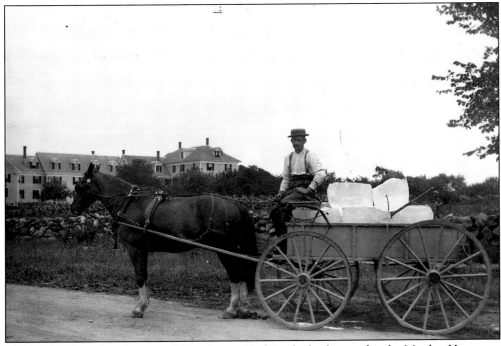

The Drake House hired man and their horse, Ned. In the background is the Marden House.

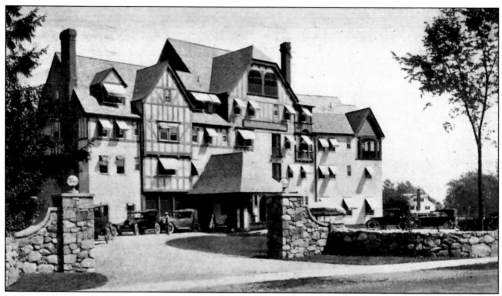

Stoneleigh Manor. Built by a community corporation in 1919 to be the most luxurious summer hotel in New England, it failed when the Drake family had to pull out their money to complete Chicago's Drake Hotel. For a while, it was an exclusive girls' school in the winter and a hotel in the summer. After World War II, it became the Atlantic Air Academy. In 1949, it was sold to the Catholic Church for $170,000, and operated as St. Francis College, and, later as a retreat house. Despite its varied uses, it remained fundamentally unchanged throughout, and walking into the building, with its custom-made Elizabethan furniture, its monogrammed silver, and the formal dining room, was like entering a timewarp. The elevator was taken to pieces during a wartime scrap metal drive in the early 1940s but the metal never left the building and noone could ever figure out how to put the elevator back together again.

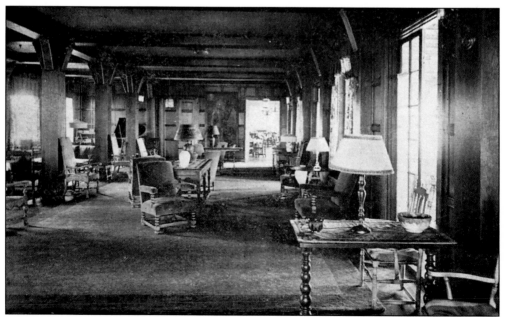

The hotel lobby at Stoneleigh Manor, which was torn down in 1998.

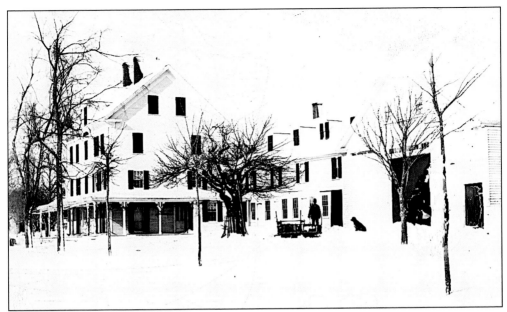

E.P. Philbrick's Rising Sun Boarding House had to be moved to make room for the construction of Stoneleigh Manor.

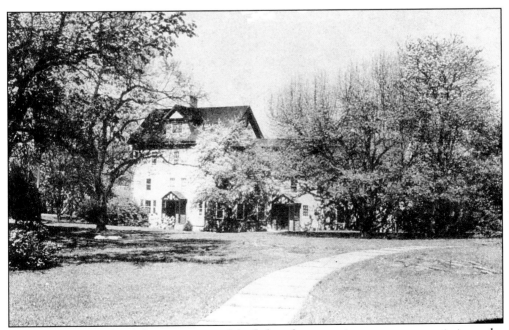

Placed on the back of the property and larded with stucco in an attempt to imitate the Elizabethan style of Stoneleigh Manor, the Rising Sun became Pioneer Hall of the Stoneleigh College era.

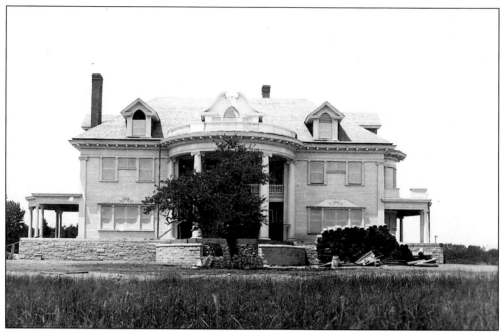

The Francis Drake estate under construction. With its great elliptical portico, the locals referred to it as the summer White House. It burned in a spectacular fire in 1968.

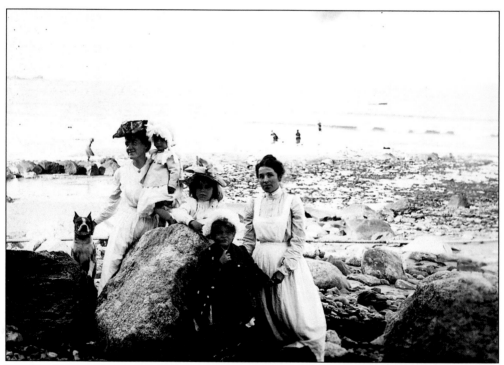

Wealthy Victorian visitors to Rye Beach would bring or hire a governess for the children. An 1871 brochure for the Ocean House states that children with adult appetites would be charged accordingly.

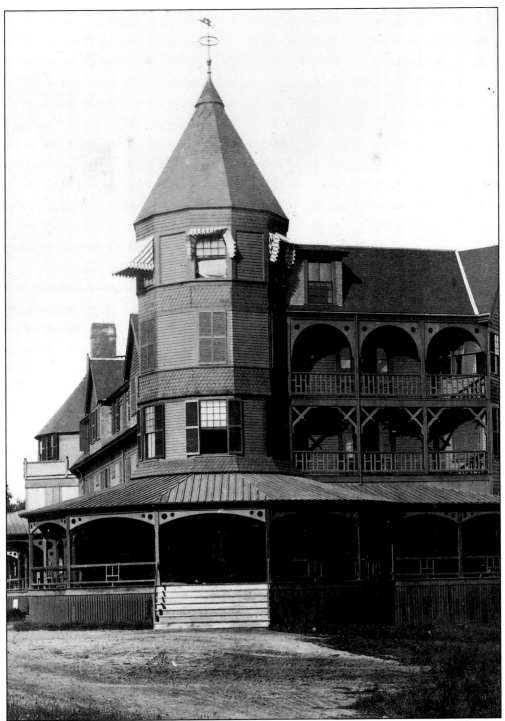

The distinctive tower of the second Farragut that was torn down in 1975. It had been a grand hotel but in the final year you could not open a window without fear that the glass would fall out. Bell hops had to bang on the pipes with a hammer to make the old ladies think that the steam heat was coming up.

Last but not least, one of Rye's unchanged prime attractions.

Acknowledgments

Since this collection spans forty years it would be impossible to mention all the sources, including museums and flea markets, that have contributed to the total. However, special recognition must be given to: the late Lena Foss Berry, who first gave me an album of her father's photographs; Garland Patch, who sold me most of my glass negatives; and Bertha Foss, who gave names to many of the faces. More recently, special thanks are due to Nancy Page, who gave me a large collection of Berry and Walker family photographs. Sincere thanks also go to Mrs. Molly Vinton, the daughter of Russell Sawyer, for her many pages of recollections on Rye Beach, and to Ms. Alice Shurcliff for permission to quote from the autobiography of her mother who spent many summers at Rye Beach as a young girl.

My early years of research owe much of their success to the first-hand accounts of the late Mrs. Shirley Philbrick, Bessie Locke, Russell Sawyer, and Abbott Drake, and the depth of information uncovered would not have been possible without the files of the *Portsmouth Herald* and the many old papers at the Boston Public Library.

Finally, much credit belongs to my wife, an English teacher, who has always worried about my spelling and punctuation, and to my parents who planted the seeds of my interest in local research and nurtured them through two previous books.